Art Studio

Faces & Features

More than 50 projects and techniques for drawing and painting heads, faces, and features in pencil, acrylic, watercolor, and more!

Brimming with creative inspiration, how-to projects, and useful information to enrich your everyday life, Quarto Knows is a favorite destination for those pursuing their interests and passions. Visit our site and dig deeper with our books into your area of interest: Quarto Creates, Quarto Cooks, Quarto Homes, Quarto Lives, Quarto Drives, Quarto Explores, Quarto Gifts, or Quarto Kids.

First Published in 2018 by Walter Foster Publishing, an imprint of The Quarto Group.
6 Orchard Road, Suite 100, Lake Forest, CA 92630, USA.
T (949) 380-7510 F (949) 380-7575 **www.QuartoKnows.com**

Walter Foster Publishing titles are also available at discount for retail, wholesale, promotional, and bulk purchase. For details, contact the Special Sales Manager by email at specialsales@quarto.com or by mail at The Quarto Group, Attn: Special Sales Manager, 401 Second Avenue North, Suite 310, Minneapolis, MN 55401 USA.

ISBN: 978-1-63322-643-2

Digital edition published in 2018
eISBN: 978-1-63322-644-9

Cover design by Eoghan O' Brien

Printed in China
10 9 8 7 6 5 4 3 2 1

TABLE OF CONTENTS

Drawing

DRAWING PAPER Drawing paper is available in a range of surface textures (called "tooth"), including smooth grain (plate finish and hot pressed), medium grain (cold pressed), and rough to very rough. Cold-pressed paper is the most versatile and is great for a variety of drawing techniques. For finished works of art, using single sheets of drawing paper is best.

SKETCH PADS Sketch pads come in many shapes and sizes. Although most are not designed for finished artwork, they are useful for working out your ideas.

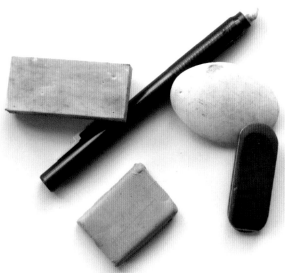

ERASERS There are several types of art erasers. Plastic erasers are useful for removing hard pencil marks and large areas. Kneaded erasers (a must) can be molded into different shapes and used to dab at an area, gently lifting tone from the paper.

TORTILLONS These paper "stumps" can be used to blend and soften small areas when your finger or a cloth is too large. You also can use the sides to blend large areas quickly. Once the tortillons become dirty, simply rub them on a cloth, and they're ready to go again.

DRAWING IMPLEMENTS

Drawing pencils, the most common drawing tool and the focus of this book, contain a graphite center. They are categorized by hardness, or grade, from very soft (9B) to very hard (9H). A good starter set includes a 6B, 4B, 2B, HB, B, 2H, 4H, and 6H. The chart below shows a variety of drawing tools and the kinds of strokes you can achieve with each one.

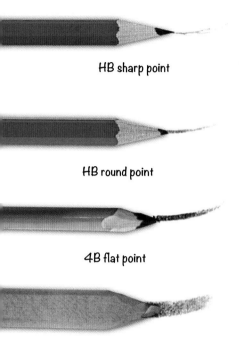

HB sharp point

HB round point

4B flat point

Flat sketching

HB An HB with a sharp point produces crisp lines and offers good control. A round point produces slightly thicker lines and is useful for shading small areas.

FLAT For wider strokes, use a 4B with a flat point. A large, flat sketch pencil is great for shading bigger areas.

CHARCOAL 4B charcoal is soft and produces dark marks. Natural charcoal vines are even softer and leave a more crumbly residue on the paper. White charcoal pencils are useful for blending and lightening areas.

CONTÉ CRAYON OR PENCIL Conté crayon is made from very fine Kaolin clay and is available in a wide range of colors. Because it's water-soluble, it can be blended with a wet brush or cloth.

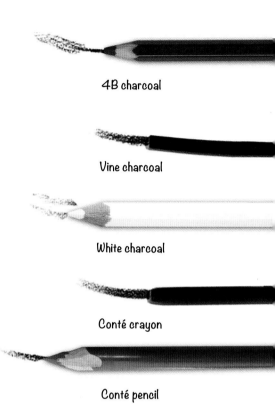

4B charcoal

Vine charcoal

White charcoal

Conté crayon

Conté pencil

SHARPENING YOUR PENCILS

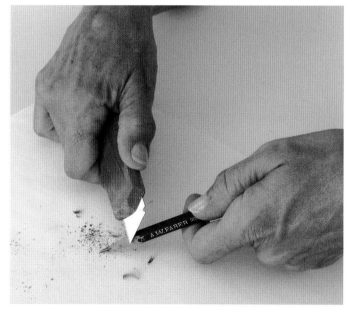

A UTILITY KNIFE Use this tool to form a variety of points (chiseled, blunt, or flat). Hold the knife at a slight angle to the pencil shaft, and always sharpen away from you, taking off a little wood and graphite at a time.

A SANDPAPER BLOCK This tool will quickly hone the lead into any shape you wish. The finer the grit of the paper, the more controllable the point. Roll the pencil in your fingers when sharpening to keep its shape even.

Oil & Acrylic

PAINTS

Paint varies in expense by grade and brand, but even reasonably priced paints offer sufficient quality. Very inexpensive paints might lack consistency and affect your results, but buying the most costly color may limit you. Find a happy medium.

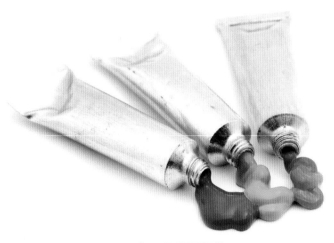

PALETTE & PAINTING KNIVES

Palette knives are mainly used for mixing colors on your palette and come in various sizes and shapes. Some knives can also be used for applying paint to your canvas, creating texture in your work, or even removing paint. Palette knives are slightly rounded at the tip. Painting knives are pointed and a bit thicker, with a slightly more flexible tip.

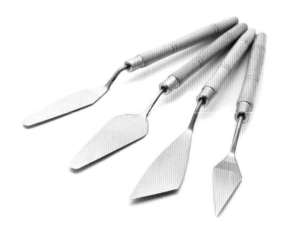

PALETTES

Palettes for acrylic range from white, plastic handheld palettes to sheets of plexiglass. The traditional mixing surface for oils is a handheld wooden palette, but many artists opt for a plexiglass or tempered glass palette. A range of welled mixing palettes are available for watercolorists, from simple white plastic varieties to porcelain dishes.

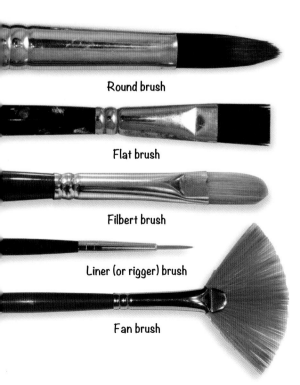

Round brush

Flat brush

Filbert brush

Liner (or rigger) brush

Fan brush

BRUSHES

Synthetic brushes are the best choice for acrylic painting because their strong filaments can withstand the caustic nature of acrylic. Sable and soft-hair synthetic brushes are ideal for watercolor. A selection of hog bristle brushes is a staple for all oil painters. Build your starter set with small, medium, and large flat brushes; a few medium round brushes; a liner (or rigger) brush; a medium filbert brush; and a medium fan brush. Brushes are commonly sized with numbers, although the exact sizes vary between manufacturers. Generally #1 to #5 are small brushes, #6 to #10 are medium brushes, and #11 and up are large brushes. Flat brushes are often sized by the width of the ferrule (or brush base), such as ¼-inch, ½-inch, and 1-inch flat brushes.

PAINTING SURFACES

Although you can paint with oils and acrylics on almost any material, from watercolor paper to wooden board, canvas is the most popular choice. Watercolor paper is the perfect surface for the fluid washes of watercolors. Many artists like using this durable paper for other wet and dry media.

MEDIUMS, SOLVENTS & ADDITIVES

Drying oils and oil mediums allow artists to change the consistency and reflective qualities of oil paint. Although you can technically paint straight from the tube, most artists add medium to extend the paint and to build an oil painting in the traditional "fat over lean" layering process. Because oil-based paints do not mix with water, artists traditionally use solvents, such as odorless mineral spirits, for paint thinning and cleanup. If you choose to purchase a solvent, be sure it is intended for fine-art purposes. Note any instructions and cautions provided by the manufacturer.

To thin and clean up acrylic and watercolor, water is the simplest medium. However, you can also find mediums and additives made specifically for these types of paint. A range of gels, pastes, and additives allow artists alter to the behavior and properties of acrylic paint, such as extending the drying time or creating a coarse texture. Watercolor mediums are less common, but some artists rely on adding ox gall, gum arabic, granulation medium, or iridescent medium to create specific effects.

ADDITIONAL SUPPLIES

Some additional supplies you'll want to have on hand include:
- Paper, pencils, and a sharpener for drawing, sketching, and tracing
- Jars of water, paper towels, and a spray bottle of water
- Fixative to protect your initial sketches before you apply paint

Watercolor

The airy and atmospheric qualities of watercolor set it apart from other painting media. Watercolor is a fluid medium that requires quite a bit of practice to master; however, if you devote enough time to this medium, you'll understand why it is praised for its ability to quickly capture an essence, suggesting form and color, with just a few brushstrokes.

TYPES OF WATERCOLOR

Watercolor is pigment dispersed in a vehicle of gum arabic (a binder), glycerin (a plasticizer to prevent dry paint from cracking), corn syrup or honey (a humectant to keep the paint moist), and water. Fillers, extenders, and preservatives may also be present. Watercolor comes in four basic forms: tubes, pans, semi-moist pots, and pencils. What you choose should depend on your painting style and preferences.

TUBES

Tubes contain moist paint that is readily mixable. This format is great for studio artists who have room to store tubes and squirt out the amount needed for a painting session. Unlike oil and acrylic, you need only a small amount of tube paint to create large washes. Start with a pea-sized amount, add water, and then add more paint if necessary.

PANS

Pans, also called "cakes," are dry or semi-moist blocks of watercolor. Many lidded watercolor palettes are designed to hold pans, making them portable and convenient. They often contain more humectant than tube paints to prevent the paint from drying out. To activate the paint, stroke over the blocks with a wet brush. To create large washes or mixes, load the brush with paint and pull color into a nearby well.

SEMI-MOIST POTS

Semi-moist pots are the most economical option. The colors sit in round pots, often in a row with a lid that serves as a mixing tray. Like pans, these gummy-looking watercolors are formulated with more humectant to retain moisture. Activate the paint by stroking over the color with a wet brush.

WATERCOLOR PENCILS

These tools combine the fluid, colorful nature of watercolor with the control of pencil drawing. Available in both wood-encased and woodless forms, they feature leads of hard watercolor that you can sharpen like any graphite pencil. They are great for creating fine details or sketching a composition for traditional watercolor painting, or you can use them with a wet brush to develop entire works.

MEDIUMS

Watercolor mediums and additives alter the characteristics of the paint. Whether you want more flow, gloss, sparkle, or texture, a number of products are available to help you achieve your desired results.

GUM ARABIC Made from the sap of an acacia tree, gum arabic is the binder of watercolor paint. When added to your jar of clean mixing water, it increases the gloss and transparency of watercolor.

OX GALL Ox gall is made of alcohol and cow bile. The medium is a wetting agent that reduces the surface tension of water and increases the fluidity of watercolor. It is particularly useful when working in large washes on hard-sized watercolor paper, as it makes the paper more readily accept paint. Add just a few drops to your jar of clean mixing water to see the effects.

LIFTING PREPARATION MEDIUM

Lifting preparation medium allows you to easily lift watercolor from your paper—even staining pigments. Apply the medium to the paper with a brush and allow it to dry; then stroke over the area with watercolor. After the paint dries, use a wet brush to disturb the wash and lift the paint away by dabbing with A tissue or paper towel. These swatches show attempts to lift permanent carmine on a surface prepped without (A) and with (B) lifting preparation (see below).

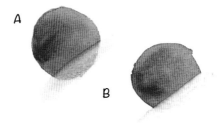

A

B

IRIDESCENT MEDIUM

Iridescent medium gives a metallic shimmer to watercolor paint. Mix a small amount into your washes, noting that a little bit goes a long way. For more dramatic results, stroke the medium directly over a dried wash.

MASKING FLUID

Masking fluid, also called "liquid frisket," is a drying liquid, such as latex, that preserves the white of the paper while you paint. This allows you to stroke freely without working around highlights. Fluids may be colored or colorless and rub-away or permanent.

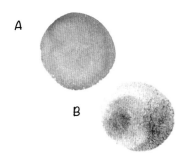

A

B

GRANULATION MEDIUM

When used in place of water in a watercolor wash, this medium encourages granulation. It is most effective when used with nongranulating colors such as modern pigments. In these examples at left, view phthalo blue with (A) and without (B) granulation medium.

Pastel

When selecting pastels, it is important to understand the different qualities of each type of pastel. There are three main types: soft, hard, and pastel pencils. Beginners should collect a large assortment of artist's-quality soft pastels (70 or more) and a smaller selection of hard pastels.

Soft Pastels

SOFT PASTELS Good-quality soft pastels are composed of almost pure pigment, with a very small amount of filler and just a touch of binder to hold them together. As a result, they are more sensitive and crumble easily. Soft pastels are incredibly brilliant, with beautiful covering strength. The degree of softness and shape varies depending on the brand. Traditional soft pastels are round, yet many are currently produced in a shorter square format. Thanks to the popularity of the pastel medium, there is an ever-growing selection of quality soft pastels on the market today. But as a beginner, you can explore the available pastels to find what works for you. Soft pastels are quite versatile and can be applied in thin glazes or in thick impasto painting techniques. They come in very large selections of up to 500 colors to choose from, including all the tints, shades, and tones. They can even be bought in sets designed specifically for landscape, portrait, or still life use. Soft pastels can also be purchased in single sticks.

HARD PASTELS Hard pastels are typically thinner and longer than soft pastels. They also contain more binder and less pigment. Hard pastels do not fill the tooth, or grain, of the paper as quickly as soft pastels, nor do they have quite the same tinting strength, yet they can be used interchangeably with soft pastel throughout a painting. Hard pastels can be sharpened to a point with a razor because of their harder consistency. They work well for a linear drawing approach, making them ideal for applying small details as well as laying in the preliminary drawing. Hard pastels are great for portrait details. Keep a selection of earth and skin tones on hand, as well as neutral accents like black and white.

Hard Pastels

PASTEL PENCILS Pastel pencils are essentially a hard pastel core in a protective wood covering. They are designed to be sharpened to a point and can be used either for detail work or sketching. You can buy pastel pencils in full sets or individually. It is beneficial to have a selection of pastel pencils on hand, though not necessary if you already have hard pastels.

Pastel Pencils

CHOOSING YOUR WORK SURFACE

As with pastel sticks, there is a vast and growing selection of pastel surfaces, including pastel papers and boards ranging from very fine to extra rough, available to the artist. Because pastel is a dry medium, surfaces that are suitable for pastel should have ample tooth (texture) to remove the pastel from the stick and adhere it to the surface. These surfaces are available in a large variety of tints and tones, as well as black and white.

TRADITIONAL PASTEL PAPERS are available in a range of beautiful tinted colors and have the necessary tooth to grab the pastel and hold it. Pastel paper is also less expensive than sanded surfaces, which makes it a great choice for pastel studies, as well as for beginners. This paper can receive multiple layers of pastel before filling the tooth, but is not as durable as the sanded surfaces. Try different papers to see which ones you like best.

SANDED PAPERS AND BOARDS have been specially primed with a toothy grit that bites and holds the pastel as it drags across the surface. They are capable of receiving almost limitless layers of pastel, and are also quite durable and able to endure much blending, erasing, and smudging. They can be mounted to a rigid substrate by your local framer, and many brands are now sold pre-mounted for a more stable work surface that is virtually indestructible. Again, there are a variety of sanded pastel papers you may want to try, so don't be afraid to explore and experiment with different types of papers to discover your favorites.

PASTEL PRIMERS contain ingredients like pumice or marble dust to make surfaces more toothy and can be applied on almost any non-oily surface, including watercolor paper, mat board, gatorboard, masonite, illustration board, canvas, and even wood panels. The toothy grit in the primer sets up the surface to receive multiple layers of pastel and can be tinted with acrylic color to create an underpainting.

Priming your own surface gives you the opportunity to create unique texture and brushwork right from the start, while tinting your underpainting at the same time with your preferred color. This is a very exciting approach for landscapes.

Pencil Techniques

HATCHING This basic method of shading involves filling an area with a series of parallel strokes. The closer the strokes, the darker the tone will be.

CROSSHATCHING For darker shading, place layers of parallel strokes on top of one another at varying angles. Again, make darker values by placing the strokes closer together.

SHADING DARKLY By applying heavy pressure to the pencil, you can create dark, linear areas of shading.

GRADATING To create gradated values (from dark to light), apply heavy pressure with the side of your pencil, gradually lightening the pressure as you stroke.

BLENDING To smooth out the transitions between strokes, gently rub the lines with a blending tool or tissue.

SHADING WITH TEXTURE For a mottled texture, use the side of the pencil tip to apply small, uneven strokes.

You can create an incredible variety of effects with a pencil. By using various hand positions and shading techniques, you can produce a world of different stroke shapes, lengths, widths, and weights.

Hatching

Crosshatching

Shading Darkly

Blending

Gradating

Shading with Texture

CREATING FORM

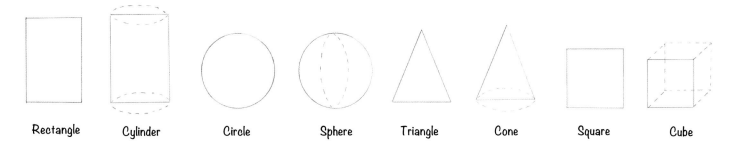

| Rectangle | Cylinder | Circle | Sphere | Triangle | Cone | Square | Cube |

The first step when creating an object is to establish a line drawing to delineate the flat area that the object takes up. This is known as the "shape" of the object.

ADDING VALUE TO CREATE FORM

A shape can be further defined by showing how light hits the object to create highlights and shadows. First note from which direction the source of light is coming. (In these examples, the light source is beaming from the upper right.)

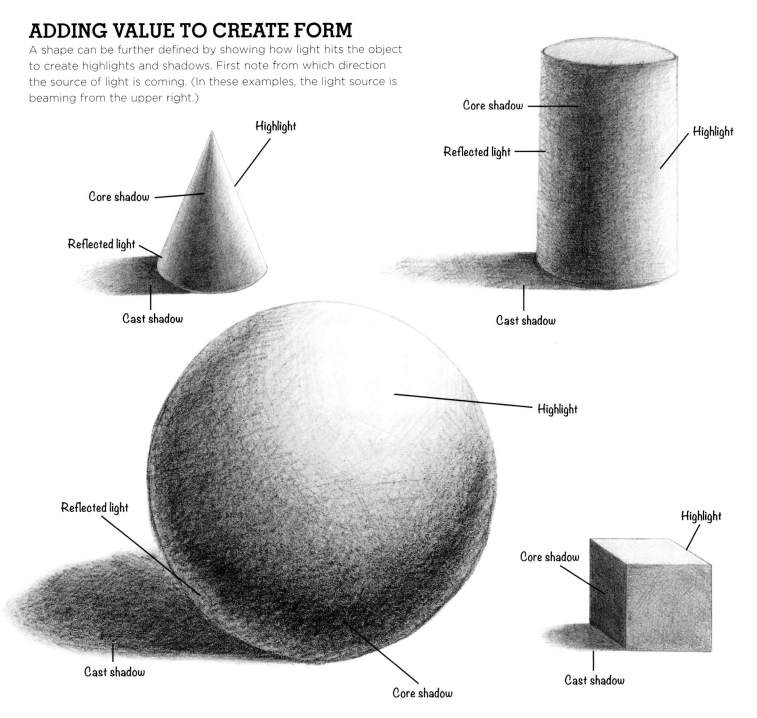

Acrylic Techniques

There are myriad techniques and tools that can be used to create a variety of textures and effects. By employing some of these different techniques, you can spice up your art and keep the painting process fresh, exciting, and fun!

FLAT WASH This thin mixture of acrylic paint has been diluted with water (use solvents to dilute oil paint). Lightly sweep overlapping, horizontal strokes across the support.

GRADED WASH Add more water or solvent and less pigment as you work your way down. Graded washes are great for creating interesting backgrounds.

DRYBRUSH Use a worn flat or fan brush loaded with thick paint, wipe it on a paper towel to remove moisture, then apply it to the surface using quick, light, irregular strokes.

STIPPLE Take a stiff brush and hold it very straight, with the bristle-side down. Then dab on the color quickly, in short, circular motions. Stipple to create the illusion of reflections.

SCUMBLE With a dry brush, lightly scrub semi-opaque color over dry paint, allowing the underlying colors to show through. This is excellent for conveying depth.

SCRAPE Using the side of a palette knife or painting knife, create grooves and indentations of various shapes and sizes in wet paint. This works well for creating rough textures.

LIFTING OUT Use a moistened brush or a tissue to press down on a support and lift colors out of a wet wash. If the wash is dry, wet the desired area and lift out with a paper towel.

IMPASTO Use a paintbrush or a painting knife to apply thick, varied strokes, creating ridges of paint. This technique can be used to punctuate highlights in a painting.

THICK ON THIN Stroking a thick application of paint over a thin wash, letting the undercolor peek through, produces textured color variances perfect for rough or worn surfaces.

MASK WITH TAPE Masking tape can be placed onto and removed from dried acrylic paint without causing damage. Don't paint too thickly on the edges—you won't get a clean lift.

DRY ON WET Create a heavily diluted wash of paint; then, before the paint has dried, dip a dry brush in a second color and stroke quickly over it to produce a grainy look.

Flat Wash

Graded Wash

Drybrush

Stipple

Scumble

Scrape

Lifting Out

Impasto

Thick on Thin

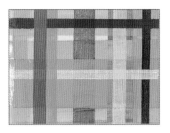
Mask with Tape

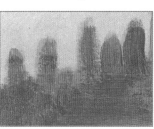
Dry on Wet

Oil Techniques

Most oil painters apply paint to their supports with brushes. The variety of effects you can achieve—depending on your brush selections and your techniques—is virtually limitless. Just keep experimenting to find out what works best for you. A few of the approaches to oil painting and brushwork techniques are outlined below.

PAINTING THICKLY Load your brush or knife with thick, opaque paint and apply it liberally to create texture.

THIN PAINT Dilute your color with thinner, and use soft, even strokes to make transparent layers.

DRYBRUSH Load a brush, wipe off excess paint, and lightly drag it over the surface to make irregular effects.

BLENDING Use a clean, dry hake or fan brush to lightly stroke over wet colors to make soft, gradual blends.

GLAZING Apply a thin layer of transparent color over existing dry color. Let dry before applying another layer.

PULLING AND DRAGGING Using pressure, pull or drag dry color over a surface to texture or accent an area.

SCUMBLING Lightly brush semi-opaque color over dry paint, allowing the underlying colors to show through.

SPONGING Apply paint with a natural sponge to create mottled textures for subjects such as rocks or foliage.

WIPING AWAY Wipe away paint with a paper towel or blot with newspaper to create subtle highlights.

SPATTER Randomly apply specks of color on your canvas by flicking thin paint off the tip of your brush.

SCRAPING Use the tip of a knife to remove wet paint from your support and reveal the underlying color.

STIPPLING Using the tip of a brush or knife, apply thick paint in irregular masses of small dots to build color.

When you're learning a new technique, it's a good idea to practice on a separate sheet first. Once you're comfortable with the technique, you can apply it with confidence to your final work.

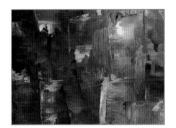
Painting Thickly

Thin Paint

Drybrush

Blending

Glazing

Pulling and Dragging

Scumbling

Sponging

Wiping Away

Spatter

Scraping

Stippling

Watercolor Techniques

Unlike other painting media, watercolor relies on the white of the paper to tint the layers of color above it. Because of this, artists lighten watercolor washes by adding water—not by adding white paint. To maintain the luminous quality of your watercolors, minimize the layers of paint you apply so the white of the paper isn't dulled by too much pigment.

GRADATED WASH A gradated (or graduated) wash moves slowly from dark to light. Apply a strong wash of color and stroke in horizontal bands as you move away, adding water to successive strokes.

BACKRUNS Backruns, or "blooms," create interest within washes by leaving behind flower-shaped edges where a wet wash meets a damp wash. First stroke a wash onto your paper. Let the wash settle for a minute or so, and then stroke another wash within (or add a drop of pure water).

WET-INTO-WET Stroke water over your paper and allow it to soak in. Wet the surface again and wait for the paper to take on a matte sheen; then load your brush with rich color and stroke over your surface. The moisture will grab the pigments and pull them across the paper to create feathery soft blends.

TILTING To pull colors into each other, apply two washes side by side and tilt the paper while wet so one flows into the next. This creates interesting drips and irregular edges.

FLAT WASH A flat wash is a thin layer of paint applied evenly to your paper. First wet the paper, and then load your brush with a mix of watercolor and water. Stroke horizontally across the paper and move from top to bottom, overlapping the strokes as you progress.

USING SALT For a mottled texture, sprinkle salt over a wet or damp wash. The salt will absorb the wash to reveal the white of the paper in interesting starlike shapes. The finer the salt crystals, the finer the resulting texture.

DRYBRUSHING Load your brush with a strong mix of paint; then dab the hairs on a paper towel to remove excess moisture. Drag the bristles lightly over the paper so that tooth catches the paint and creates a coarse texture.

USING A SPONGE In addition to creating flat washes, sponges can help you create irregular, mottled areas of color.

SPATTERING Load your brush with a wet wash and tap the brush over a finger to fling droplets of paint onto the paper. You can also load your brush and then run the tip of a finger over the bristles to create a spray.

USING ALCOHOL To create interesting circular formations within a wash, use an eyedropper to drop alcohol into a damp wash. Change the sizes of your drops for variation.

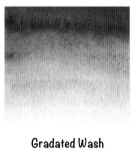

Gradated Wash

Backruns

Wet-Into-Wet

Tilting

Flat Wash

Salt

Drybrushing

Sponge

Spattering

Alcohol

MIXING WATERCOLORS

WET-ON-DRY This method involves applying different washes of color on dry watercolor paper and allowing the colors to intermingle, creating interesting edges and blends.

MIXING IN THE PALETTE VS. MIXING WET-ON-DRY To experience the difference between mixing in the palette and mixing on the paper, create two purple shadow samples. Mix ultramarine blue and alizarin crimson in your palette until you get a rich purple; then paint a swatch on dry watercolor paper (A). Next paint a swatch of ultramarine blue on dry watercolor paper. While this is still wet, add alizarin crimson to the lower part of the blue wash, and watch the colors connect and blend (B). Compare the two swatches. The second one (B) is more exciting. It uses the same paints but has the added energy of the colors mixing and moving on the paper. Use this mix to create dynamic shadows.

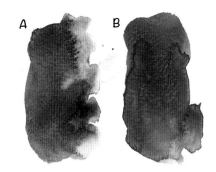

VARIEGATED WASH A variegated wash differs from the wet-on-dry technique in that wet washes of color are applied to wet paper instead of dry paper. The results are similar, but using wet paper creates a smoother blend of color. Using clear water, stroke over the area you want to paint and let it begin to dry. When it is just damp, add washes of color and watch them mix, tilting your paper slightly to encourage the process.

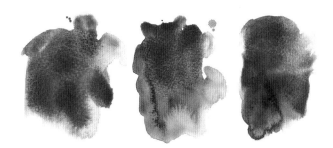

APPLYING A VARIEGATED WASH After applying clear water to your paper, stroke on a wash of ultramarine blue (left). Immediately add some alizarin crimson to the wash (center), and then tilt to blend the colors further (right). Compare this with your wet-on-dry purple shadow to see the subtle differences caused by the initial wash of water on the paper.

GLAZING is a traditional watercolor technique that involves two or more washes of color applied in layers to create a luminous, atmospheric effect. Glazing unifies the painting by providing an overall underpainting (or background wash) of consistent color.

CREATING A GLAZE To create a glazed wash, paint a layer of ultramarine blue on your paper (far left). Your paper can either be wet or dry. After this wash dries, apply a wash of alizarin crimson over it (near left). The subtly mottled purple that results is made up of individual glazes of transparent color.

Pastel Techniques

UNBLENDED STROKES To transition from one color to another, allow your pastel strokes to overlap where they meet. Leaving them unblended creates a raw, energetic feel and maintains the rhythm of your strokes.

BLENDING To create soft blends between colors, begin by overlapping strokes where two colors meet. Then pass over the area several times, using a tissue, chamois, or stump to create soft blends.

GRADATING A gradation is a smooth transition of one tone into another. To create a gradation using one pastel, begin stroking with heavy pressure and lessen your pressure as you move away from the initial strokes.

STROKING OVER BLENDS You can create rich colors and interesting contrasts of texture by stroking over areas of blended pastel.

SCUMBLING This technique involves scribbling to create a mottled texture with curved lines. Scumble over blended pastel for extra depth.

MASKING Use artist tape to create clean edges in your drawings or to mask out areas that should remain free of pastel.

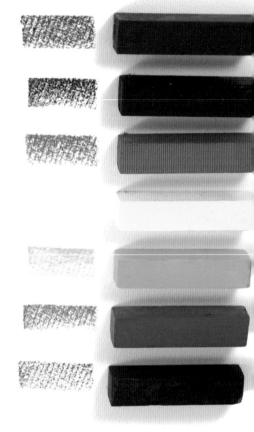

Generally used alongside soft pastel, hard pastel is less vibrant and is best for preliminary sketches and small details. Like soft pastel, hard pastel is available in both sticks and pencils.

Unblended Strokes

Blending

Gradating

Stroking over Blends

Scumbling

Masking

Transferring a Drawing

There are many options available to transfer a subject image onto drawing paper or canvas, including using transfer paper, the grid method, or the projector method.

TRANSFER PAPER

On a sheet of thin drawing or tracing paper, sketch out your composition until you are satisfied. Take a piece of transfer paper (sold in art stores) and tape it over the white paper surface you have chosen for your final drawing. There is a coating of graphite on the bottom of the transfer paper. Tape your drawing or tracing paper over the transfer paper. Using a ballpoint pen or stylus, impress the outlines of your drawing with medium pressure. Raise both papers, and you will see the graphite image on your final white paper. Erase the transferred graphite lines if needed as you develop the drawing. Of course, you can always freehand your composition directly onto the final paper. Sketch lightly and erase well.

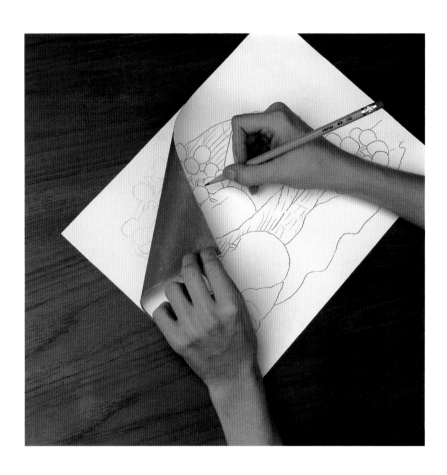

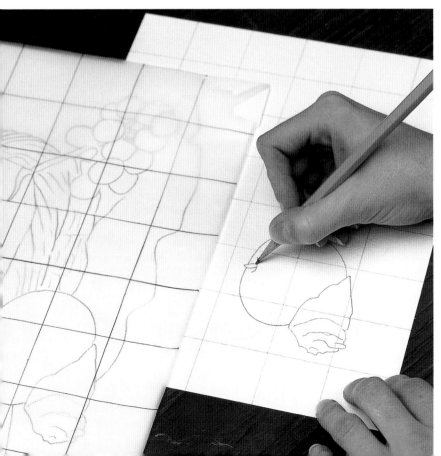

GRID METHOD This method enables you to sketch out your drawing in small segments using one-inch squares. Photocopy your photo reference and draw a grid of one-inch squares over the photocopy with a pen and ruler. Then very lightly draw the same grid of one-inch squares with a graphite pencil onto your final drawing paper. Starting from left to right, draw what you see in each square. Connect your composition from box to box until it is done. Erase your grid lines.

PROJECTOR METHOD Secure your projector to a countertop and tape your photo inside its top. The photo reflects off a lighted mirror, through a lens, and onto your final paper. Trace the basic outlines of the photo onto your drawing paper. Once the sketch is on paper, you can then focus on creating a perfectly proportioned piece as you refine lines, add detail, and build up tone.

Color Theory

Acquaint yourself with the ideas and terms of color theory, which involve everything from color relationships to perceived color temperature and color psychology. In the following pages, we will touch on the basics as they relate to painting.

COLOR WHEEL

The color wheel, pictured to the right, is the most useful tool for understanding color relationships. Where the colors lie relative to one another can help you group harmonious colors and pair contrasting colors to communicate mood or emphasize your message. The wheel can also help you mix colors efficiently. Below are the most important terms related to the wheel.

Primary colors are red, blue, and yellow. With these you can mix almost any other color; however, none of the primaries can be mixed from other colors. *Secondary colors* include green, orange, and violet. These colors can be mixed using two of the primaries. (Blue and yellow make green, red and yellow make orange, and blue and red make violet.) A *tertiary color* is a primary mixed with a near secondary, such as red with violet to create red-violet.

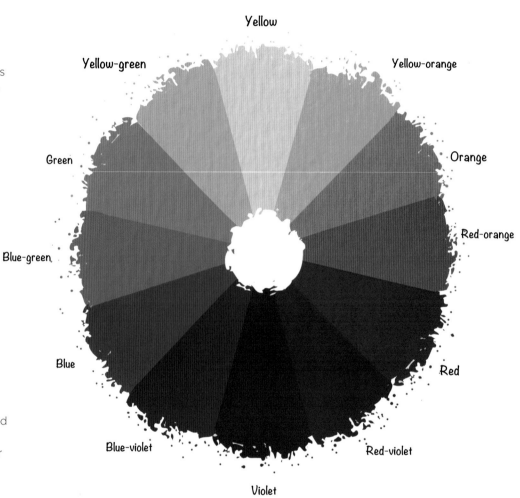

COMPLEMENTARY COLORS are those situated opposite each other on the wheel, such as purple and yellow. Complements provide maximum color contrast.

ANALOGOUS COLORS are groups of colors adjacent to one another on the color wheel, such as blue-green, green, and yellow-green. When used together, they create a sense of harmony.

NEUTRAL COLORS are browns and grays, both of which contain all three primary colors in varying proportions. Neutral colors are often dulled with white or black. Artists also use the word "neutralize" to describe the act of dulling a color by adding its complement.

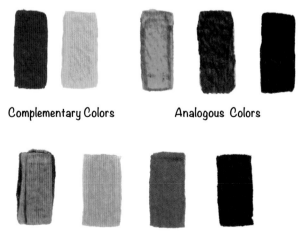

Complementary Colors Analogous Colors

Neutral Colors

Color Temperature

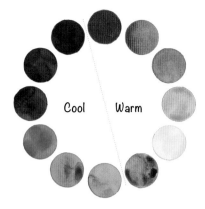

Cool | Warm

Divide your color wheel in half by drawing a line from a point between red and red-violet to a point between yellow-green and green. You have now identified the warm colors (reds, oranges, and yellows) and the cool colors (greens, blues, and purples). Granted, red-violet is a bit warm and yellow-green is a bit cool, but the line needs to be drawn somewhere, and you'll get the general idea from this. In a painting, warm colors tend to advance and appear more active, whereas cool colors recede and provide a sense of calm. Remember these important points about color temperature as you plan your painting.

MOOD & TEMPERATURE

We are all affected by color, regardless of whether we realize it. Studies show that color schemes make us feel certain ways. Warm colors, such as red, orange, yellow, and light green, are exciting and energetic. Cool colors, such as dark green, blue, and purple, are calming and soothing. Use these color schemes as tools to express the mood of the painting. In fact, you'll find that you don't even need a subject in your painting to communicate a particular feeling; the abstract works below demonstrate how color is powerful enough to stand on its own.

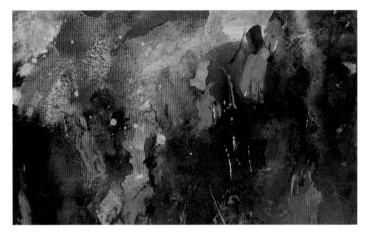

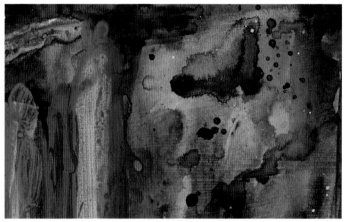

WARM PALETTE What is this painting of? Who knows! It doesn't matter. The point here is to express a mood or a feeling. Here the mood is hot, vibrant passion. Energetic reds and oranges contrast the cool accents of blue and purple.

COOL PALETTE A much different feeling is expressed in this painting. It is one of calm and gentle inward thought. The red-orange accents create an exciting counterpoint to the overall palette of cool greens and blues.

Color isn't the only thing that affects mood. All parts of the painting contribute to the mood of the piece, including the brushstrokes and line work. Keep these points in mind as you aim for a specific feeling in your paintings.

UPWARD STROKES (heavier at the base and tapering as they move up) suggest a positive feeling.

VERTICAL STROKES communicate force, energy, and drama.

DOWNWARD STROKES (heavier at the top and tapering as they move down) suggest a more somber tone.

HORIZONTAL STROKES denote peace and tranquility.

CHAPTER 1
PORTRAIT TECHNIQUES

Shadows & Highlights

This drawing of the head was deliberately kept in halftone (a middle value of graphite) so you can see the elements of shading more easily, without the darkest darks.

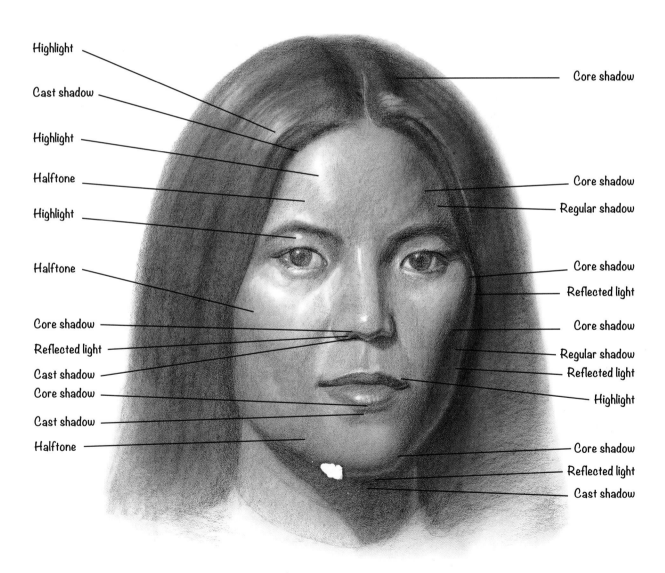

Highlight

Cast shadow

Highlight

Halftone

Highlight

Halftone

Core shadow

Reflected light

Cast shadow

Core shadow

Cast shadow

Halftone

Core shadow

Core shadow

Regular shadow

Core shadow

Reflected light

Core shadow

Regular shadow

Reflected light

Highlight

Core shadow

Reflected light

Cast shadow

How to Light the Model

Always use one dominant light on your model. It's okay to have some general light in the room, but several competing lights directed at the model will create forms that are flat or hard to read. Below are two drawings of the same woman done with two different lighting styles. One creates a harsh look with distinct shadows and more contrast (high-contrast side lighting); the other produces a more delicate image (low-contrast front lighting).

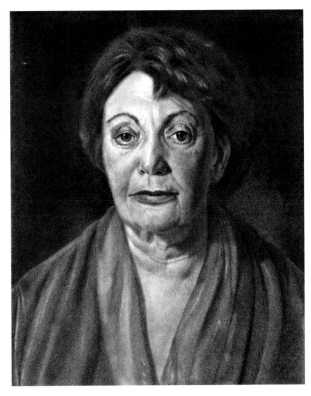

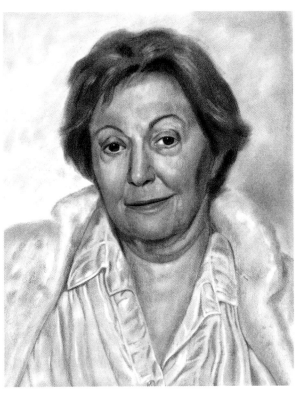

SIDE LIGHTING This portrait was drawn in a dark room with one light positioned to the model's right. This style makes the model look older and more serious, as the contrasts create harsh shadows, deepening and creating lines on the face and neck. This type of lighting is best for giving a model an air of power.

FRONT LIGHTING This method involves using a well-lit room with one light positioned in front of the model. When using this method, position the light as far away as possible to avoid hurting the model's eyes.

ENHANCING EXPRESSION

To emphasize the characteristics brought out by each type of lighting, here are a few tricks:

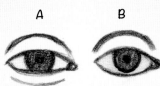

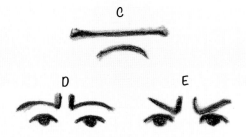

Be careful with slight smiles—they tend to look odd. Try to be a little bolder and make your smiles unambiguous. In the front-lit drawing, notice the clear, gradual arc for the lips.

In the front-lit drawing, the lower eyelids are raised so the bottom of the iris is a bit flattened (A), which suggests a smile. In contrast, showing the bottom of the iris creates a serious eye (B).

The model's intelligence is emphasized in the side-lit drawing by the pushing up of the lower lip in judgment (C) and by the furrow between the eyes (D). Be careful not to lower the eyebrows—this would make her look mean (E).

Anatomy of the Head

Knowing the anatomy of the head will help you understand the basic forms beneath the skin. Listing the names of the points on the skull isn't practical for our purpose here. Instead, there is a dot at each point of the skull that you should be aware of when you draw. These points make an impression on the surface, and, if you include them, your drawings will be more accurate.

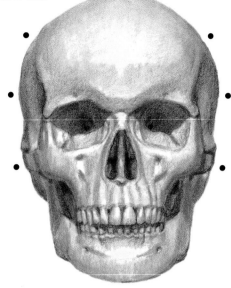

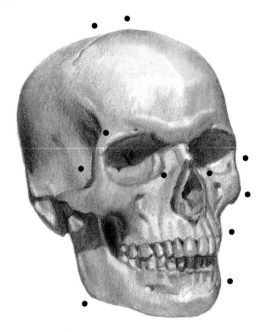

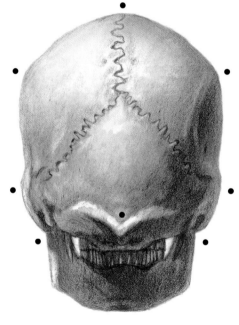

The diagram directly below includes the temporalis (on the temple) and the masseter (on the jaw) muscles. These muscles allow you to chew by pulling the jawbone. The illustration below right is a general (though not complete) diagram of the facial muscles so you can see the shapes of the muscles that lay over the bone.

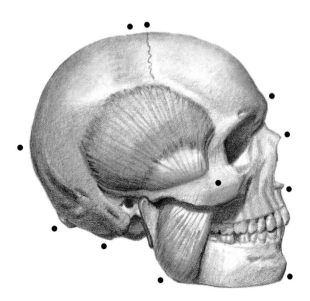

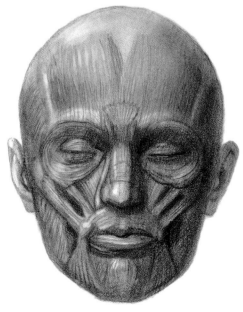

FACIAL MUSCLES & EXPRESSIONS

Below is a list of the most important muscles used in facial expressions. Familiarizing yourself with them will help you understand how the muscles move to affect the shapes and bulges of the skin.

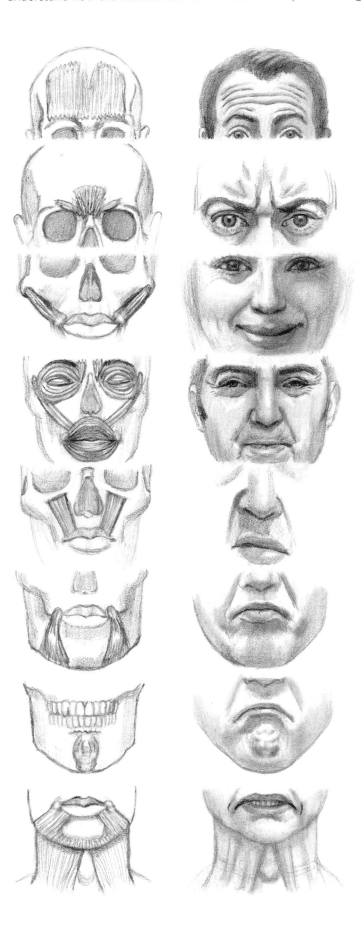

◀ The *frontalis* contracts to create wrinkles on the forehead. It can contract in the middle alone (indicating sadness) or in the middle and on the sides (indicating surprise).

◀ The *procerus* is in the middle of the brow ridge; the *corrugator* is on each side, like little wings. The *orbiculares oculi* (see below) work together with these muscles to create a frown.

◀ The *zygomaticus major* is anchored on each cheekbone and inserts into a node at each side of the lips. When they pull, they widen and raise the lips, forcing a cheek bulge under each eye. These are the main muscles for smiling.

◀ The (eye) and the *orbicularis oris* (mouth) squeeze and narrow the eyes and mouth. They also close the eyes and mouth, respectively.

◀ Each *levator* is anchored to the skull and yanks up the side of the lip so you can sneer at other artists' drawings.

◀ The *triangularis* muscles are anchored on the jaw and tug at the nodes on the sides of the lips, pulling down the corners of the mouth.

◀ The *mentalis* is anchored below the teeth and pulls up the flesh of the chin. This creates a pout or the appearance of someone thinking (mental—get it?).

◀ The *platysma* is anchored to the fascia of the muscles on the chest. It goes up and over the front of the neck to the bottom lip and lip nodes. It tugs hard on the lips for extreme expressions. On the neck, it can contract itself into cords that stand out dramatically.

General Proportions

Proportion (the comparative sizes and placement of parts to one another) is key to creating a likeness in your drawing. Although proportions vary among individuals, there are some general guidelines to keep in mind that will help you stay on track. Before you study the diagrams and tips below, memorize these two most important guidelines:

1. The face is usually divided into thirds: one-third from the chin to the base of the nose, one-third from the nose to the brow ridge, and one-third from the brow ridge to the hairline.

2. The midpoint of the head from the crown to the chin aligns with the tear ducts.

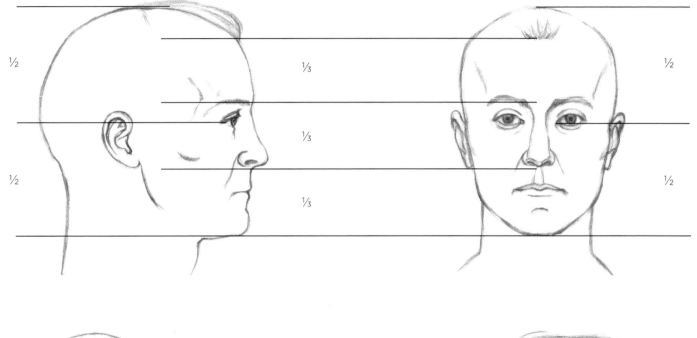

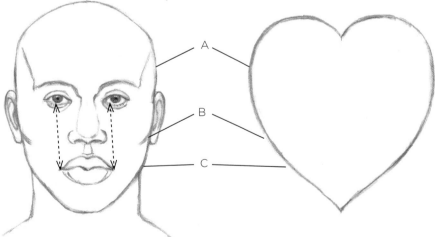

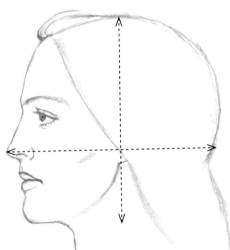

The mouth is usually the same width as the distance between the pupils. This particular model's tear ducts are higher than the midpoint.

Heads are somewhat heart shaped. The temple (A) is wider than the cheekbone (B), which is wider than the jawline (C).

Generally, the distance between the tip of the nose and back of the head is longer than the distance from the top of the head to the bottom of the head.

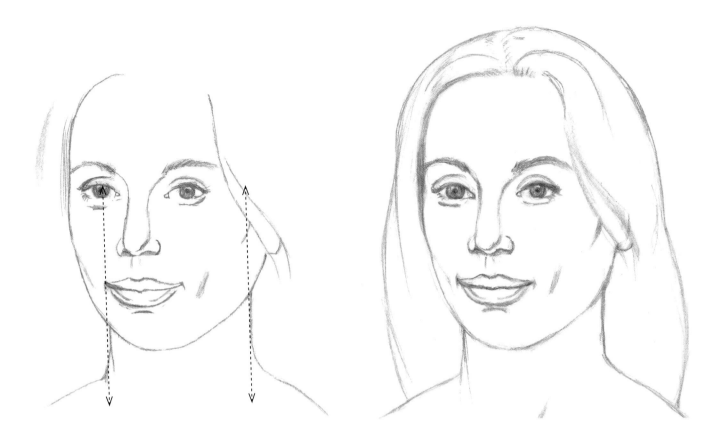

To determine the width of the neck, use the features directly above each side of the neck to serve as guides for placement. To easily see this, hold up your pencil vertically in front of you, lining it up with the side of the model's neck.

PROPORTION SUBTLETIES

- The neck pitches forward slightly.
- The neck doesn't narrow as it goes up to the jaw.
- You can usually fit another eye between the eyes.
- If you've diligently measured and the model's face is asymmetrical or involves different proportions than these, that's okay. These are guidelines—not strict rules.

Planes of the Head

It's helpful to approach the head with a general idea of what can be expected. With practice, you will automatically check for the basic forms and plane changes described below. Memorizing the planes early on will save you time.

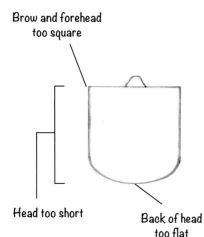

Brow and forehead too square

Head too short

Back of head too flat

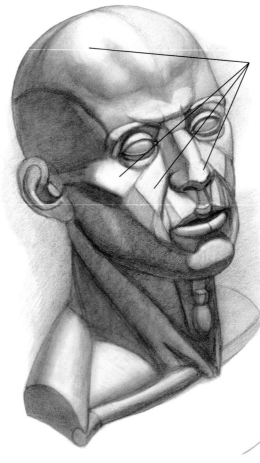

The light is brightest on the planes that are perpendicular to the light source.

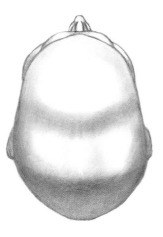

▲ Artists unfamiliar with the top view of the head make errors at the brow, with the shape of the forehead, and in the head's overall length and width.

▶ The neck doesn't narrow at the top, and it isn't concave at the sides (A). The body's forms bulge out (B). They can be flat but not concave (except in tiny transitions that are barely visible).

A

B

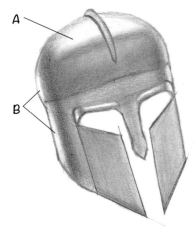

A

B

The face wedges toward the nose like this helmet. Notice the exaggerated highlights (A) and reflected light (B) on the metal.

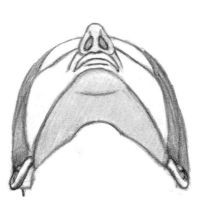

This illustration shows how the face wedges toward the center.

This illustration shows a flatter face and sharper angles at the sides of the head.

Shifts in Guidelines

When drawing the tilted head, it's essential to first measure to find the midpoint to see where it has shifted (A). Next draw lines to indicate the new positions of the features (B). A bit of shading is applied to make the horizontal lines easier to judge by.

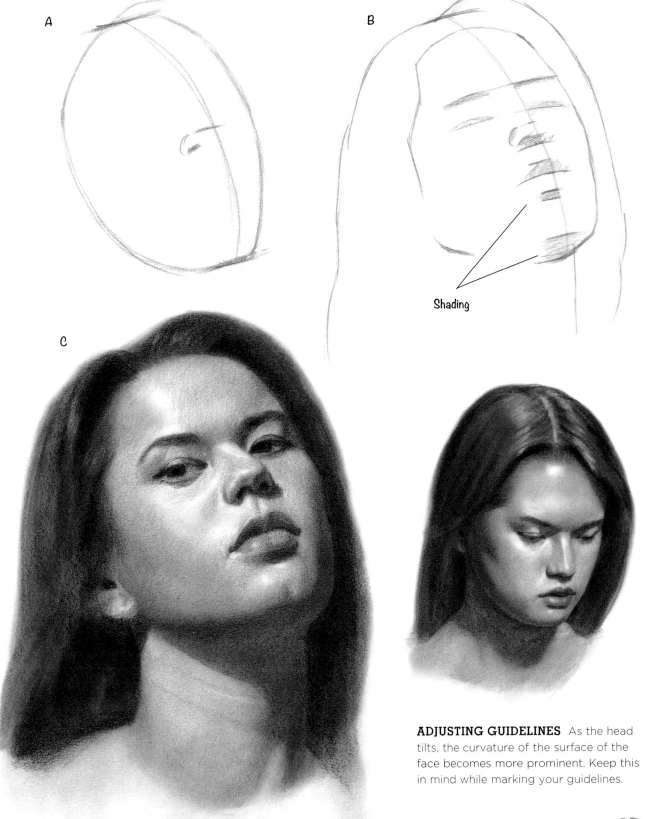

Shading

C

ADJUSTING GUIDELINES As the head tilts, the curvature of the surface of the face becomes more prominent. Keep this in mind while marking your guidelines.

Facial Features

Now that you are acquainted with the basic forms and proportions of the head, let's examine the individual features that make up the face.

EARS

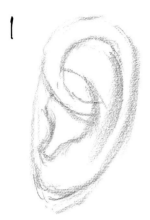

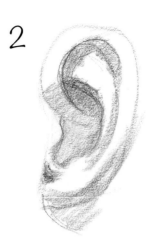

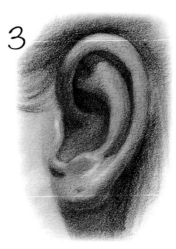

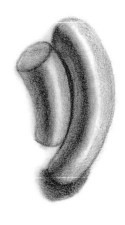

1 Draw a rough lay-in of the ear.

2 Then apply tone to indicate the shadows.

3 Stump and then lift out highlights to polish.

Each form has core and cast shadows and highlights.

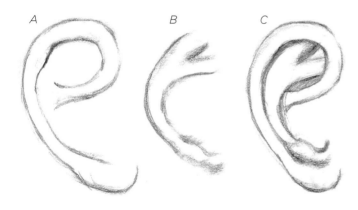

A *B* *C*

Memorize shapes A and B; combine them to create C. This gives you a basic outline to work with.

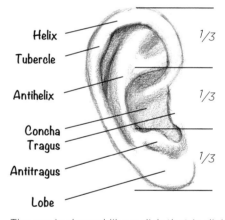

Helix
Tubercle
Antihelix
Concha
Tragus
Antitragus
Lobe

1/3
1/3
1/3

The ear is shaped like a disk that is divided into thirds.

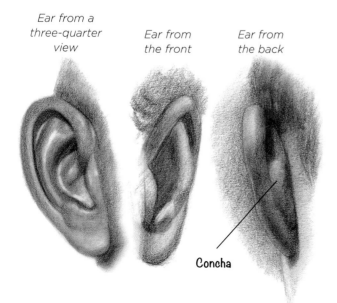

Ear from a three-quarter view

Ear from the front

Ear from the back

Concha

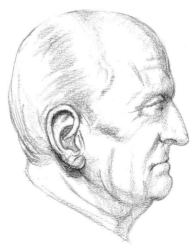

Elderly people usually have much larger ears and noses.

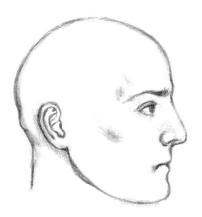

Ear too far back

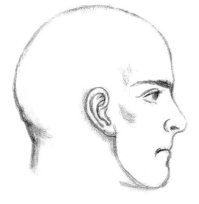

Ear too far forward

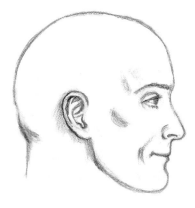

Ear is just right.

▶ The ear is situated between the brow and the base of the nose. It tends to be more in line with the lower part of the eyebrow, not the arch.

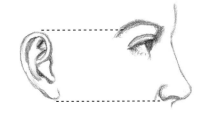

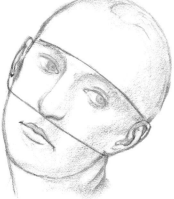

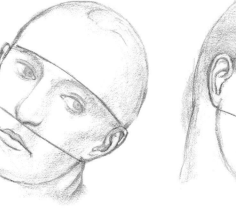

▶ There's a soft transition of the jaw from the lobe to the neck. The back of the jawline isn't sharp.

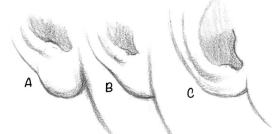

A B C

▲ Earlobes can hang (A), be attached (B), and even be underdeveloped (C).

▶ People who are overweight often have lobes that are pushed out from their faces.

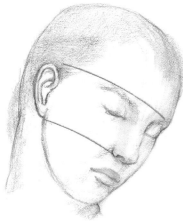

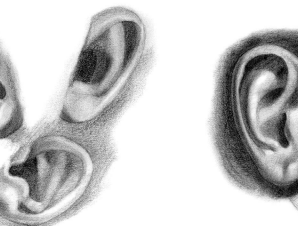

▶ A baby's ears tend to be rounder and more concave than an adult's.

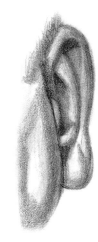

Ears have a confounded habit of having extra forms. Notice the doubled helix and two lumps on this lobe.

31

EYES

1

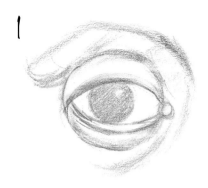

2

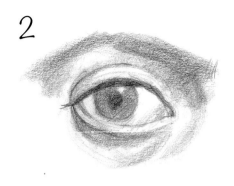

3

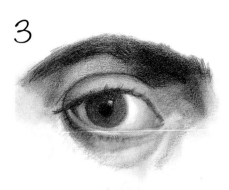

1 Lay in the size, location, and folds of the eye.

2 Build the volume by adding tone for the form and cast shadows.

3 Stump, pull out highlights, and give clarity to edges.

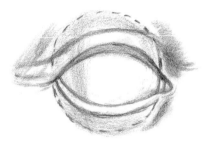

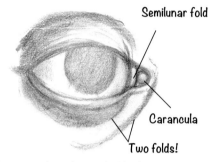

Semilunar fold

Carancula

Two folds!

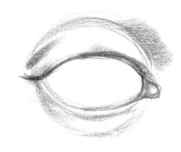

When drawing the eye, always begin by drawing a sphere and wrapping the lids over it.

There are two forms in the inner corner of the eye; hence there are two highlights!

The outer corner of the eye is usually higher than the inner corner. The upper lid overlaps the lower lid at the outer corner.

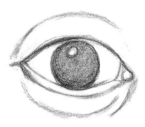

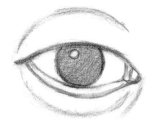

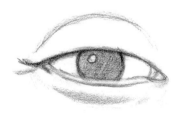

Showing the top of the iris looks unnatural.

The lid should always partially cover the top of the iris.

When a person smiles, even more of the iris is covered (especially at the bottom).

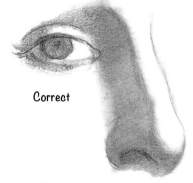

Correct

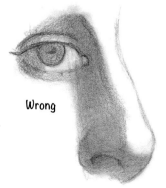

Wrong

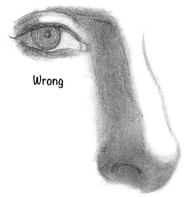

Wrong

To correctly place the eye in relation to the nose, there must be a side plane between the nose and the eye.

Don't make the mistake of letting the eye creep up the side of the nose.

Don't place the eye at the top of the nose. The eye is to the side of the nose.

▲ The eyebrows start vertically and end horizontally.

▲ The eyebrow is rarely the same tone all the way across because it's located on both the front and side of the face.

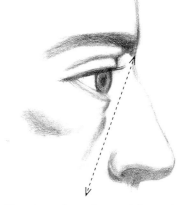

▲ There's a clear diagonal from the brow to the cheek.

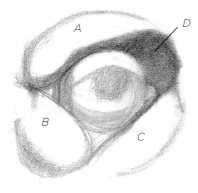

▲ A, B, and C are bulging forms surrounding the eye; D is concave.

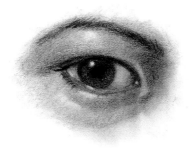

▲ This eye has additional deposits of fat within the eye socket. It also has an extra fold of skin above the inner corner that combines with the upper lid.

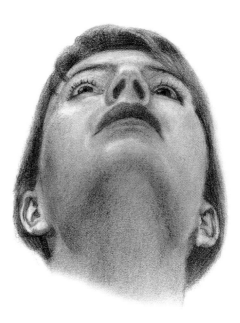

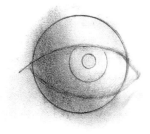

▲ The eye must be shaded as if it were a sphere. There's shading in the "whites" of the eye. They're only white where the sphere receives direct light, so shade this area to avoid flatness.

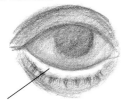

Don't forget this plane. Any line where the lower lid meets the eyeball is subtle.

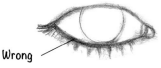

Wrong

A big black line and no plane.

▲ If the entire eye socket is in shadow, you should make the "white" of the eye darker.

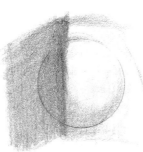

▲ The eye is on the corner of the face.

▲ From this angle, the outer corners of the eyes are lower than the inner corners.

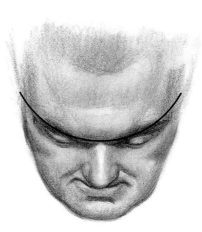

▲ The eyes are on an arc.

NOSE

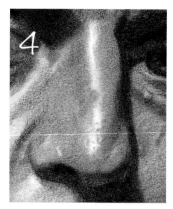

1 Check the nose's vertical angles and size compared with other features.

2 Identify the planes and forms of the nose.

3 Add tone to the nose to represent the core and cast shadows.

4 Stump and then pull out highlights for a realistic effect.

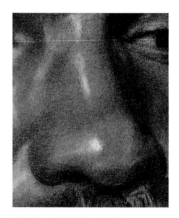

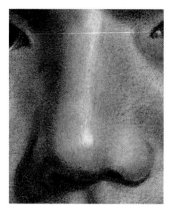

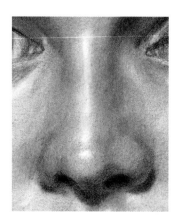

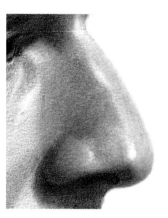

NOSE VARIATIONS Noses come in a wide variety of shapes. Notice the differences among the noses above.

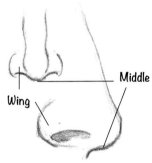

▲ The middle of the nose is usually lower than the wings.

Wing Middle

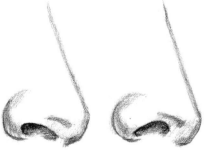

▲ Note how changing the angle of the nostril (the opening) affects the character of the nose.

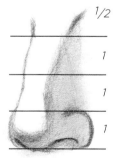

1/2

1

1

1

▲ The height of the nose is about 3½ wings high.

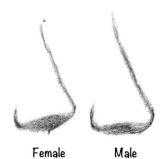

Female Male

Female noses tend to be smaller and tilted upward a bit when compared with a male's.

Remember to delineate the core shadows and the cast shadows.

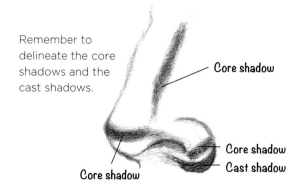

Core shadow

Core shadow
Cast shadow

Core shadow

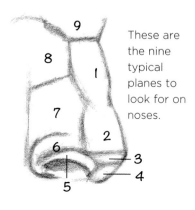

These are the nine typical planes to look for on noses.

9

8

1

7

2

6

3

5

4

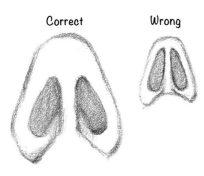

Correct Wrong

▲ The nostrils don't extend to the tip.

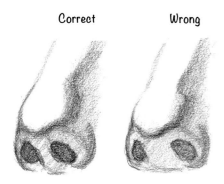

Correct Wrong

▲ The space between the nostrils is narrow.

Looking down on the nose

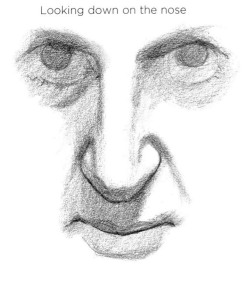

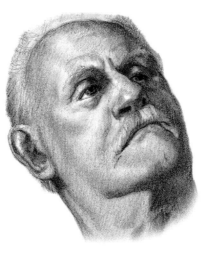

▲ Be ruthless about just how close the tip of the nose is to the eye when your model is looking up! The distance diminishes.

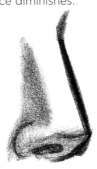

▲ Avoid drawing big, thick, black outlines around the light side of the nose.

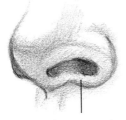

The wing of the nose has a ridge that wraps underneath to the middle of the nose.

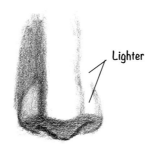

Lighter

Notice that both nostrils can't be the same tone and that one side of the nose must be lighter (with side lighting).

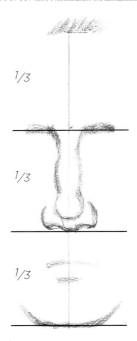

1/3

1/3

1/3

▲ The nose is approximately one-third of the face: one-third chin to nose, one-third nose to brow, one-third brow to hairline.

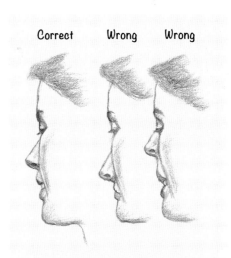

Correct Wrong Wrong

Carefully place the nose at the correct level before developing it. The seven-eighths view (shown above and below) is especially tricky.

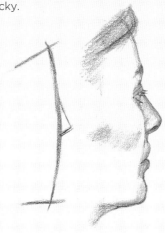

Make simple forms before adding character.

MOUTH

1

1 Lay in the size, location, and angle of the mouth.

2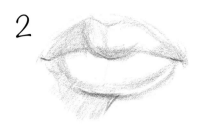

2 Build the volume and add tone for the core and cast shadows.

3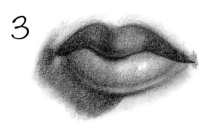

3 Stump and then pull out highlights for a polished look.

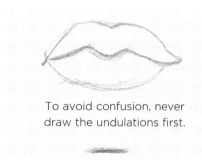

To avoid confusion, never draw the undulations first.

Always draw the size and angle first.

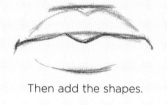

Then add the shapes.

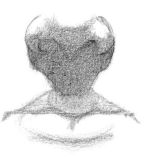

If you light a woman from above, she gets a mustache. Try to avoid this.

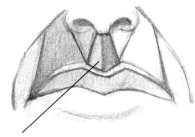

This area is called the "philtrum."

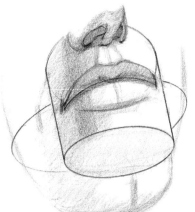

The mouth isn't flat. It's stretched over a cylindrical muzzle.

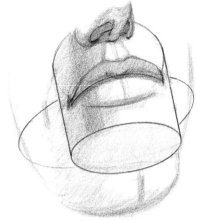

▲ The mouth is usually closer to the nose than it is to the chin.

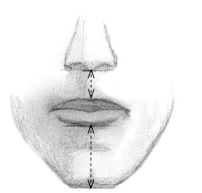

Mouth shown from below

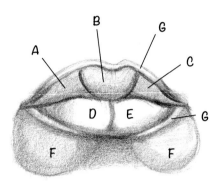

There are three forms for the upper lip (A, B, C); two forms for the lower lips (D, E); and two "pillars" underneath (F). Note the ridges above and below the lips—they often get their own highlights (G).

Wrong Correct Wrong

▲ The middle of the lips is directly below the middle of the nose.

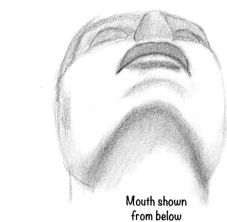

A. Dimple
B. Nasolabial fold
C. Commissural furrow
D. A gradual slope—not a line. The line is below at C.

"Sargent greater than Ribera?
We're takin' this outside!"

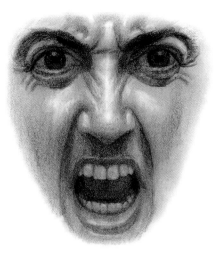

"You actually want to buy a painting?"

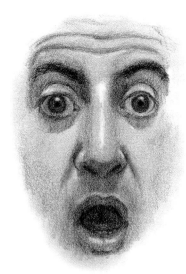

"This book's gotta be done in one
month? Yikes!"

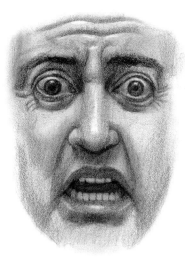

THE MOUTH AND EXPRESSION The mouth assumes predictable shapes for the emotions. Note the square for anger, the small circle for surprise, and the trapezoid for fear. The examples above were drawn with the aid of a mirror—a great tool for checking the veracity of an expression.

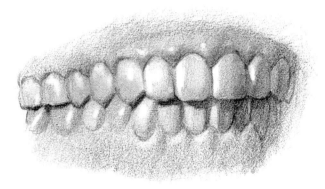

Every tooth
has a highlight.

Curve and shade those teeth back, or the teeth will jut forward at the corners, and you'll get a toothy grin.

Err on the side of too light when adding lines between teeth.

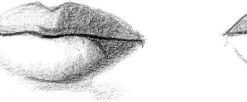

It's rare for both sides of the
muzzle to be the same shade.

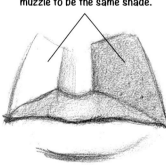

When lit from the side, the lips darken as the forms turn away from the light source. (Notice the sharp-edged shadow cast from the upper lip onto the lower lip on the shadowed side.)

Because the top lip faces down and the bottom lip faces up, they're rarely the same shade.

These three planes
are usually in shadow.

▶ Portraitists often get lazy with the lips. You must accentuate the details. Look at the reflected light on the corners of the upper lip. The reflected light tends to show up under the core shadow, and the line between the lips isn't a line—it's a cast shadow.

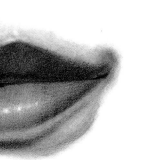

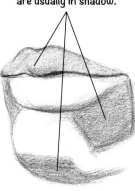

HAIR

Don't think of hair as a series of lines or squiggles—instead, treat it as a mass with texture. Following the steps and tips below will help you draw it realistically.

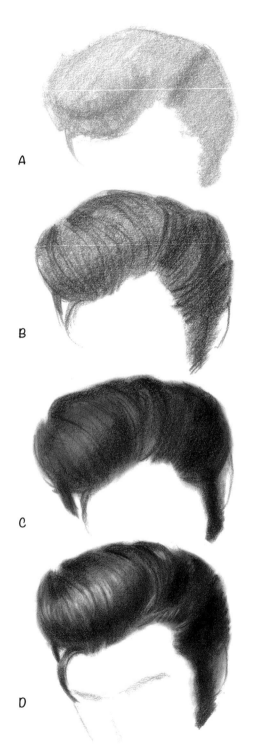

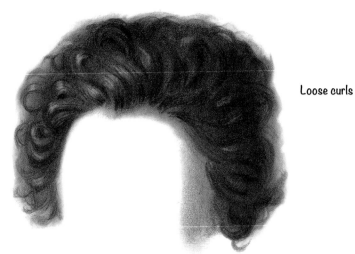

Loose curls

CURLY HAIR

When encountering curly hair, don't panic. You don't have to draw every curl. Just lay down a tone and draw a few curls. Highlight some of them, and deepen some of them. Have fun with it.

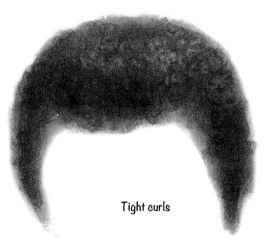

Tight curls

DRAWING HAIR Lay in a pattern of light and dark with core shadows (A). Add striations and details of the forms (B). Stump and rub; then reinforce the striations (C). Form a kneaded eraser into a point and pull out highlights. Erase parallel striations of light to mimic hair (D). The highlights in black hair aren't white.

◄ **SHADOWS IN HAIR** Core shadows aren't smart enough to stop when they get to the hairline. They keep going through the hair.

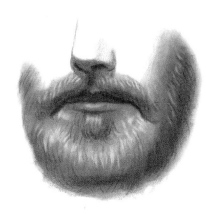

CREATING BEARDS Beards aren't cotton candy—you must bear in mind a structure as you render the volumes.

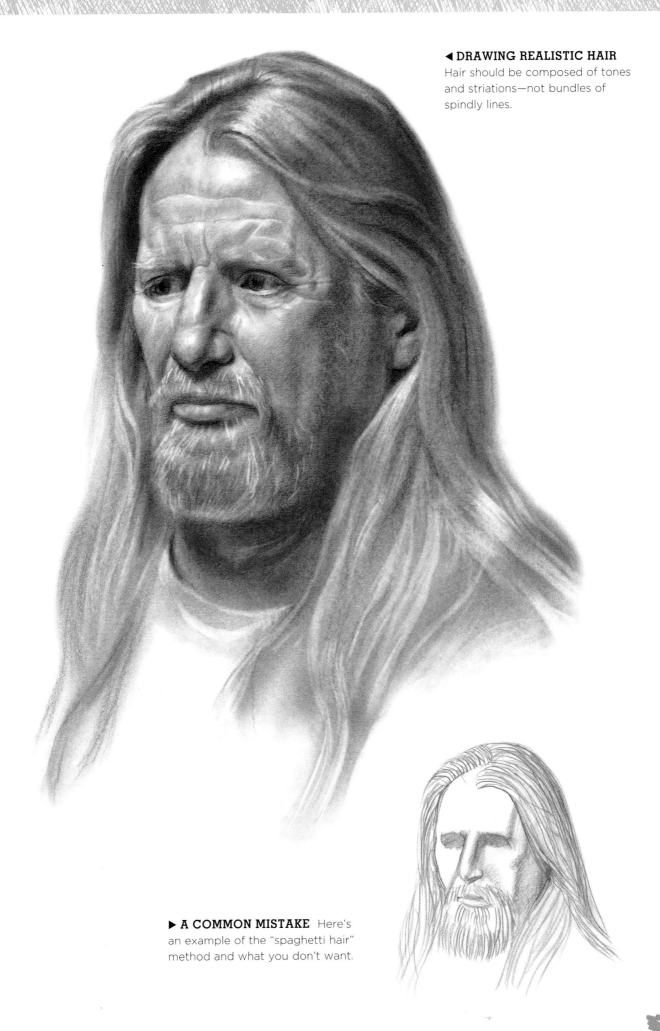

◀ **DRAWING REALISTIC HAIR**
Hair should be composed of tones and striations—not bundles of spindly lines.

▶ **A COMMON MISTAKE** Here's an example of the "spaghetti hair" method and what you don't want.

CHAPTER 2
BASIC SKETCHING

Drawing from Life

Having models pose for you as you draw— or life drawing—is an excellent way to practice rendering faces.

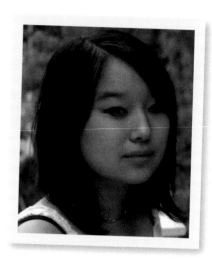

1

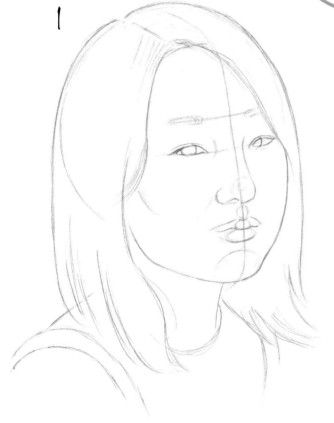

2

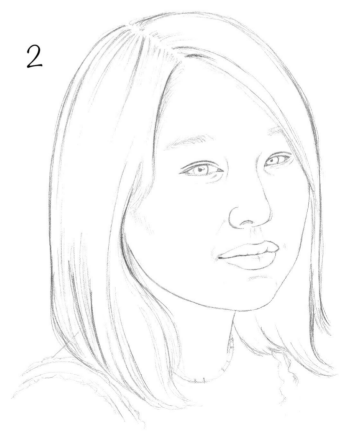

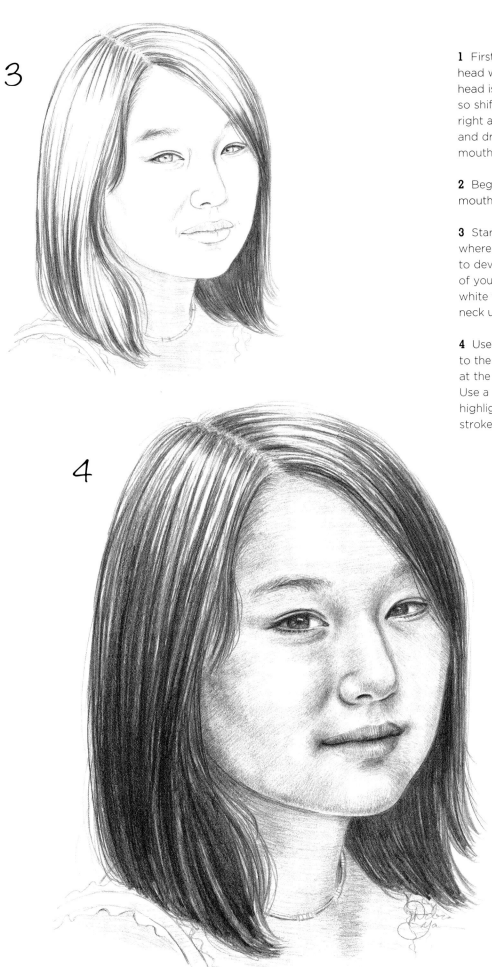

3

4

1 First, place the basic shape of the head with an HB pencil. The subject's head is tilted at a three-quarter angle, so shift the vertical centerline to the right a bit. Foreshorten the left eye, and draw only one nostril. Make the mouth smaller on the left side.

2 Begin to develop the eyes, nose, mouth, and eyebrows.

3 Start shading the face in the areas where the shadows lie. Use a 2B pencil to develop the hair, varying the length of your strokes and leaving some areas white for highlights. Then shade the neck using light, horizontal strokes.

4 Use a 3B pencil to add darker values to the hair, leaving the lightest areas at the top to show the light source. Use a kneaded eraser to lift out some highlights on the face and soften any strokes that are too dark.

Drawing a Baby

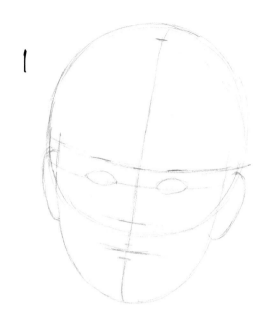

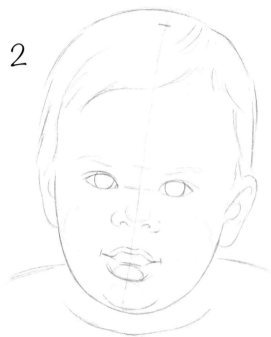

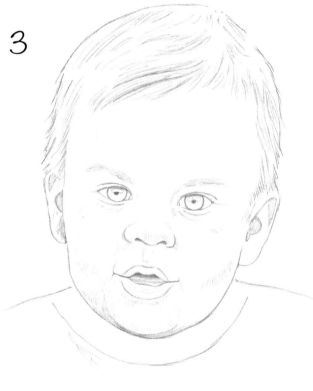

1 Using an HB pencil, block in the cranial mass and the facial guidelines. The head is tilted downward and turned slightly to the left. Place the eyebrows at the horizontal centerline and the eyes in the lower half of the face.

2 Add hair using soft, short strokes and a B pencil. Draw the open mouth; then add large irises and suggest the small nose. Draw a curved line under the chin to suggest chubbiness; then indicate the shoulders.

3 Add pupils and highlights to the eyes with a B pencil. Lightly sketch more of the hair and eyebrows; then shade under the chin. Shade inside the ears, refine the lips, and shade the upturned mouth.

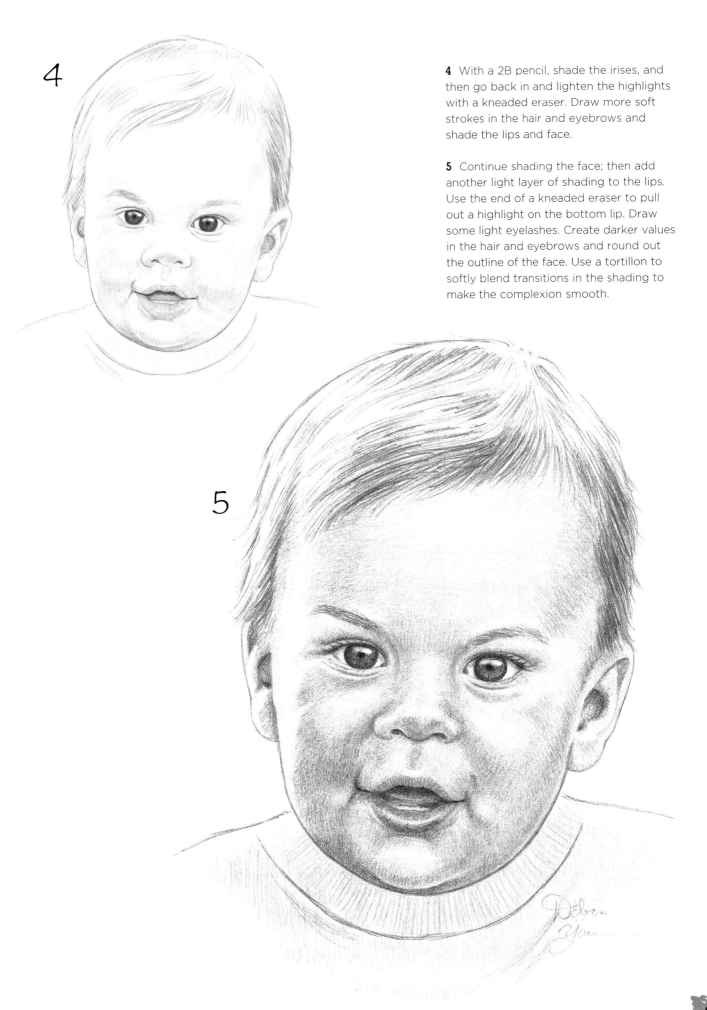

4

4 With a 2B pencil, shade the irises, and then go back in and lighten the highlights with a kneaded eraser. Draw more soft strokes in the hair and eyebrows and shade the lips and face.

5 Continue shading the face; then add another light layer of shading to the lips. Use the end of a kneaded eraser to pull out a highlight on the bottom lip. Draw some light eyelashes. Create darker values in the hair and eyebrows and round out the outline of the face. Use a tortillon to softly blend transitions in the shading to make the complexion smooth.

5

Drawing a Child

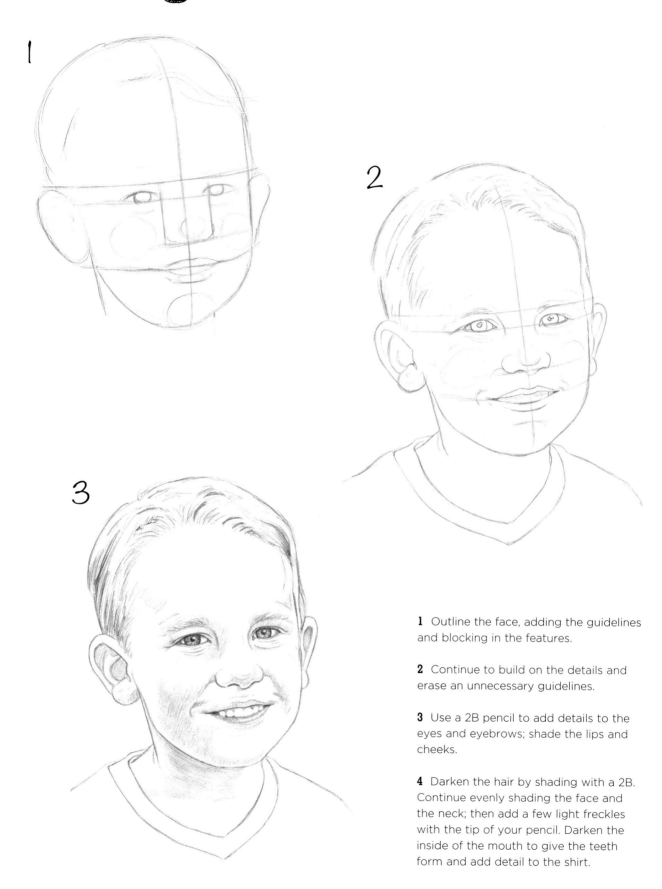

1 Outline the face, adding the guidelines and blocking in the features.

2 Continue to build on the details and erase an unnecessary guidelines.

3 Use a 2B pencil to add details to the eyes and eyebrows; shade the lips and cheeks.

4 Darken the hair by shading with a 2B. Continue evenly shading the face and the neck; then add a few light freckles with the tip of your pencil. Darken the inside of the mouth to give the teeth form and add detail to the shirt.

4

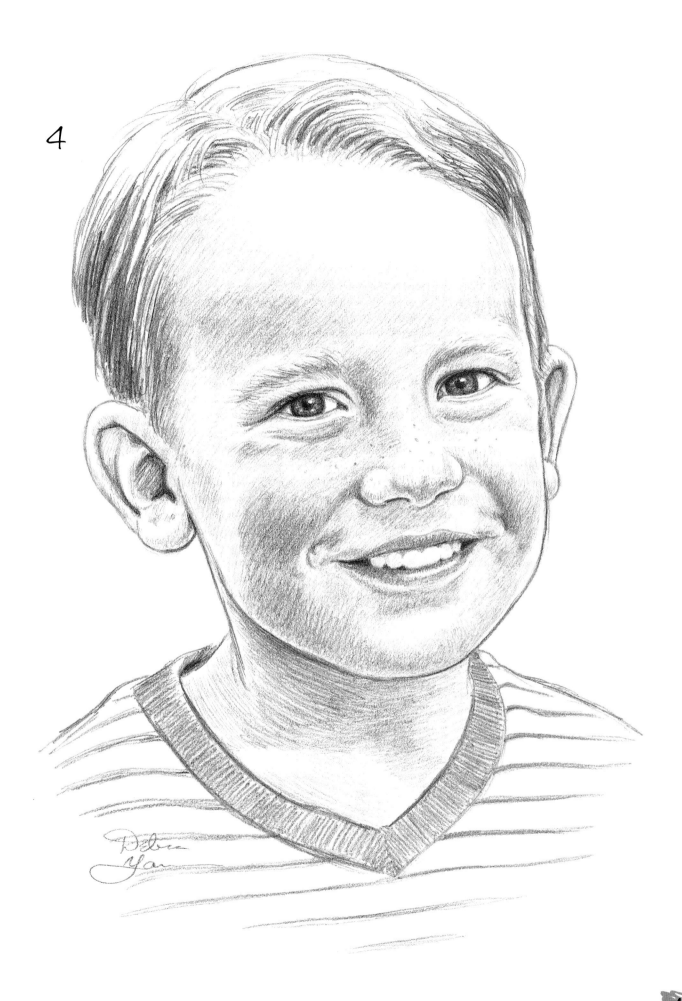

Rendering Dark Skin Tones

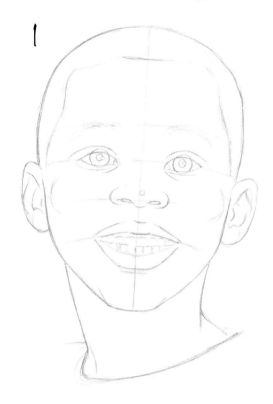

When depicting dark skin tones, pay attention to the value of the skin tone and how it compares with the values of the features; for example, when the skin is dark, the lips need to be shaded more heavily.

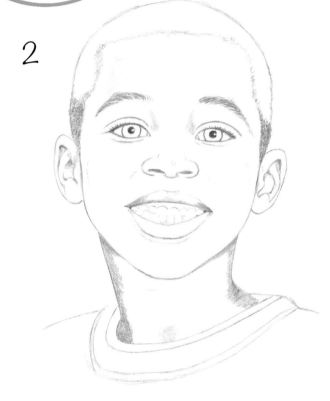

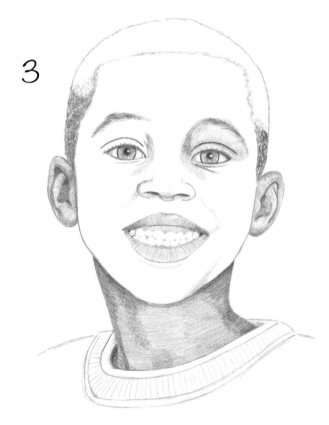

1 With a 2B pencil, block in the basic head shape and place the features; then block in the teeth and indicate the hairline, eyebrows, and ears. Sketch the curved neck and define the chin. Then develop the eyes, ears, and teeth. Block in the hairline and neck.

2 Shade the nose, neck, and top lip. Using quick, circular strokes, start to render the short, curly hair. Then detail the eyebrows, eyes, and neckband of the shirt.

3 Continue shading the lips; then shade the gums, working around the teeth. Build up the hair with more circular strokes. Then move to the neck, using horizontal lines that curve with its shape. Notice how these lines overlap and blend into the shading.

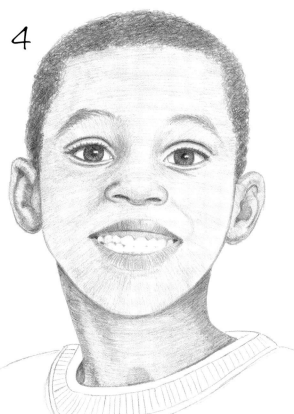

4

4 Apply a light layer of shading over the entire face, always varying the direction of your strokes as necessary to follow the shapes of the different planes.

5 Continue shading the face, making the sides of the forehead a bit darker and leaving the middle area lighter to show where the light hits. Then darken the nose, leaving a highlight on the tip. Refine the shirt, curving the strokes as they go around the back of the collar. Next further shade the lips; then pull out a highlight on the top lip with a kneaded eraser. Finally go back and soften the transitions between values by very lightly blending them with a kneaded eraser.

5

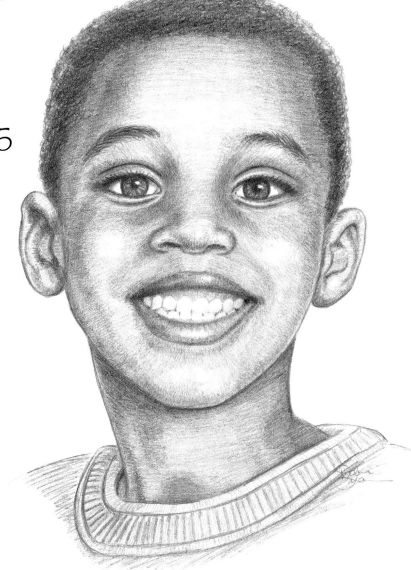

GRAPHITE PENCIL

The projects on pages 48-69 were rendered using 9B, 5B, and 2B pencils.

Young Man

The projects on pages 48-69 are broken down into seven stages of drawing: the lay-in, plumb lines, volume, edges and outlines, tonal pattern, finishing, and polishing. This first project provides the most detail on these seven stages.

STAGE 1 THE LAY-IN and plumb lines steps ensure the success of the drawing. You can always adjust your shading, but the first measurements must be exact to achieve a likeness.

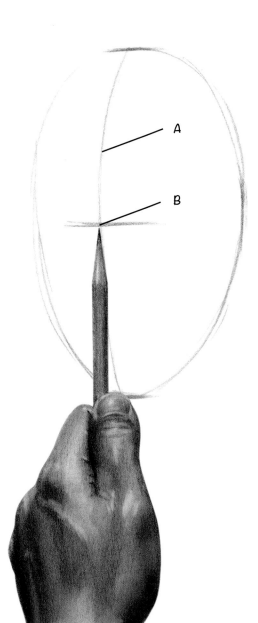

Draw an oval; then add a vertical arc (A) that follows the curvature of the model's face. Place horizontal marks at the top, bottom, and midpoint (B) of the oval. Next determine the midpoint of the model's face by extending your arm—elbow locked—and placing the tip of the pencil where you imagine the center to be and placing your thumbnail in line with the model's chin (see diagram below).

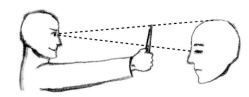

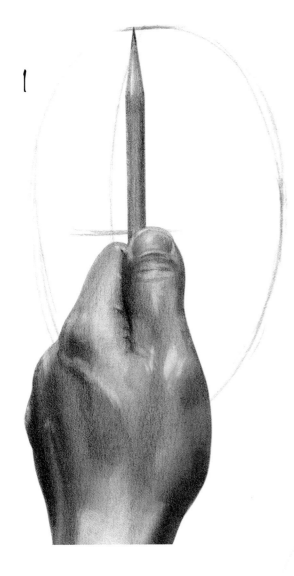

Now raise your arm so that your thumbnail is where the tip of the pencil was. If the tip is now at the top of the model's head, you've found the center. If not, simply keep adjusting the pencil and your thumb, repeating steps 1 and 2 until your nail and the tip consistently fall halfway up the model's face (the midpoint).

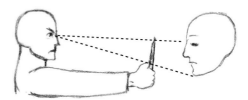

Note the form that you found at the midpoint of the face (for example, the tear ducts). Then use this to guesstimate the distances of other features from top to bottom, including hairline to brow ridge, eyes to bottom of nose, lips to chin, top to brow ridge, nose to chin, and so on.

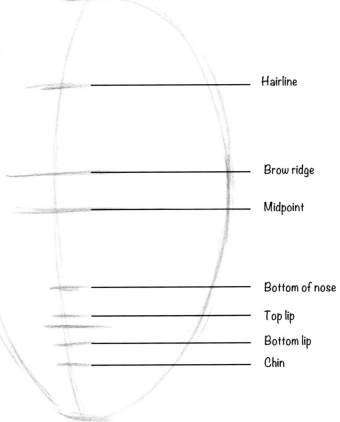

Hairline

Brow ridge

Midpoint

Bottom of nose

Top lip

Bottom lip

Chin

STAGE 2 PLUMB LINES Now you can work on the widths. Always work out the vertical measurements first because it's easy to narrow a form but big trouble to lengthen one (in this case, everything has to move).

Use your eyes to guesstimate a rough shape that would fit between the marks you measured. This will not be a precise outline. We just want a shape that has the basic width and size of the model's features. To do this, first mark a width for each feature that corresponds to the marks you made for the lay-in (A). Then compare general sizes: How much space does the nose occupy on the face? Which takes up more space—the lips or one eye? Compare back and forth between the features. Then begin to suggest the basic shape of each feature (B).

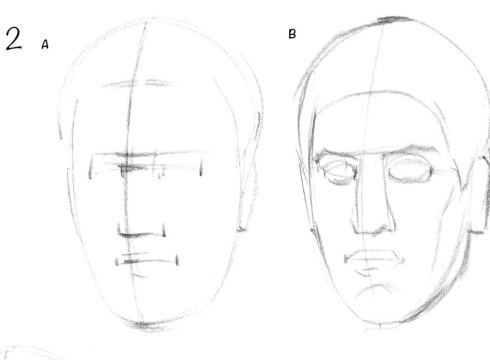

2 A B

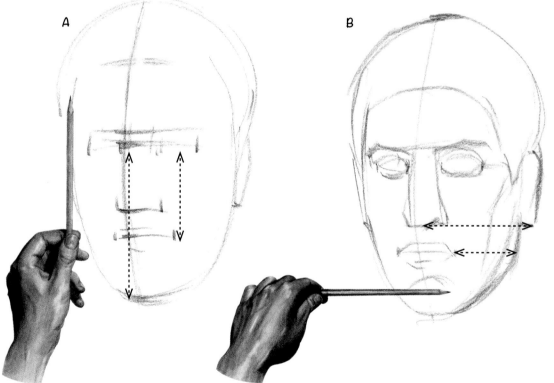

A B

Now use plumb lines to make sure the forms are aligned properly above and below one another. Wouldn't it be helpful to know if the tear ducts are directly above the nostrils? Does the side of the neck line up directly below the corner of the mouth? Put your pencil in front of the model's face vertically and check (A). Then place the pencil horizontally to gauge the alignments, including earlobe to nose, mouth to corner of jaw, and so on (B). Adjust the drawing accordingly.

Pay attention to *negative space* (the space between the forms). If you ignore it, you won't achieve a likeness and may never figure out why. The space between the forms is as important as the forms themselves. Continue checking these distances as you draw.

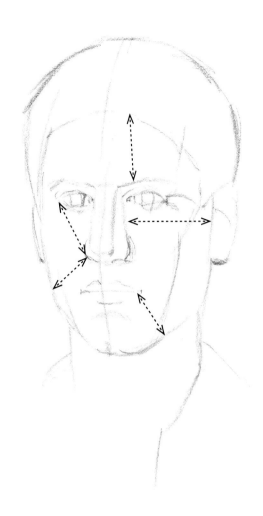

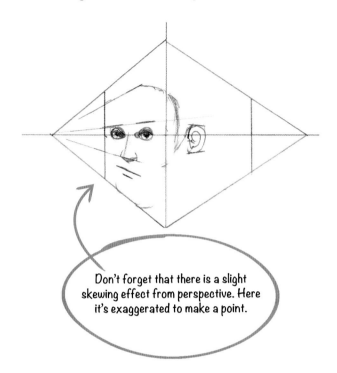

Don't forget that there is a slight skewing effect from perspective. Here it's exaggerated to make a point.

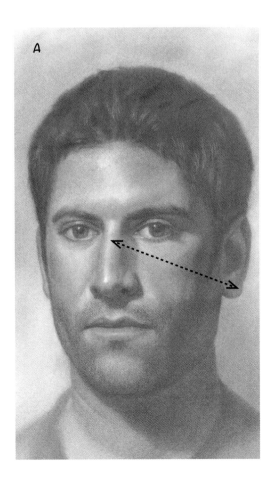

A

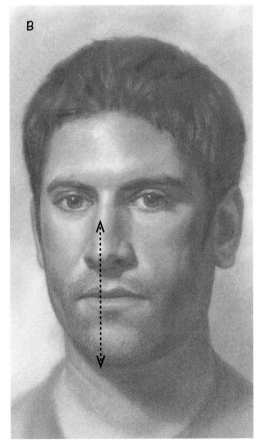

B

Always compare the two key measurements above. Hold your pencil out and have your thumbnail touch the bridge of the nose while the tip touches the ear (A). Now turn the pencil and see how this length compares with the same point on the nose to the chin (B).

DRAWING VOLUMES

Michelangelo either imagined or faintly drew volumes before he began shading. At this stage in the drawing, we will follow him. It's true that he uses obvious outlines in his drawing, but I think he did this to make the drawing hyper clear so he could easily refer to it to create a mural (the final painting on the Sistine Chapel). Be sure to keep your outlines much lighter as you draw.

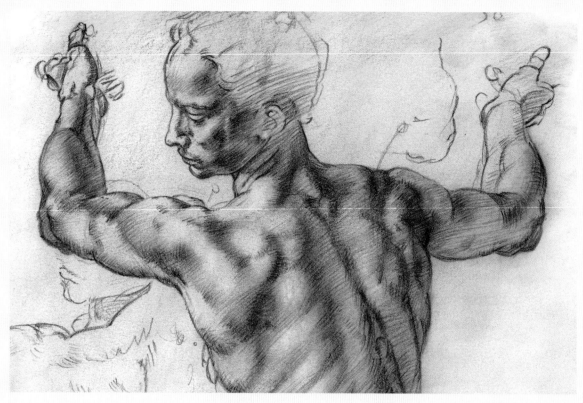

My study for the *Libyan Sibyl* on the Sistine Chapel (after Michelangelo).

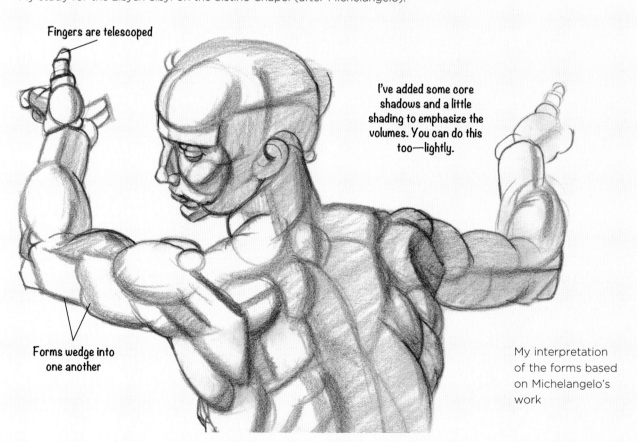

Fingers are telescoped

I've added some core shadows and a little shading to emphasize the volumes. You can do this too—lightly.

Forms wedge into one another

My interpretation of the forms based on Michelangelo's work

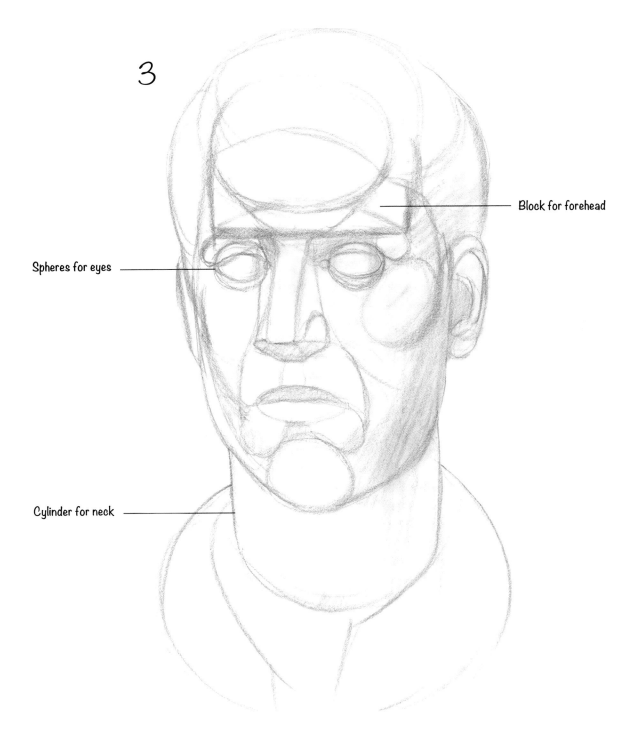

3

Block for forehead

Spheres for eyes

Cylinder for neck

STAGE 3 VOLUMES With an accurate lay-in on the paper, there's no chance of making a huge mistake, so you can relax and develop the structure on top of the plan. Faintly draw a simple volume that might protrude beneath the surface of each form. If the model were hollow, the volumes could fit inside the skin; but they are obscured by the surface of the skin. Therefore, you will shade over the volumes, erase them, and leave them, depending on what makes the drawing look more real. Having them there initially gives you a guide—a framework upon which to add details and lighting. You can't be distracted by the surface because the volumes remind you of the mass underneath.

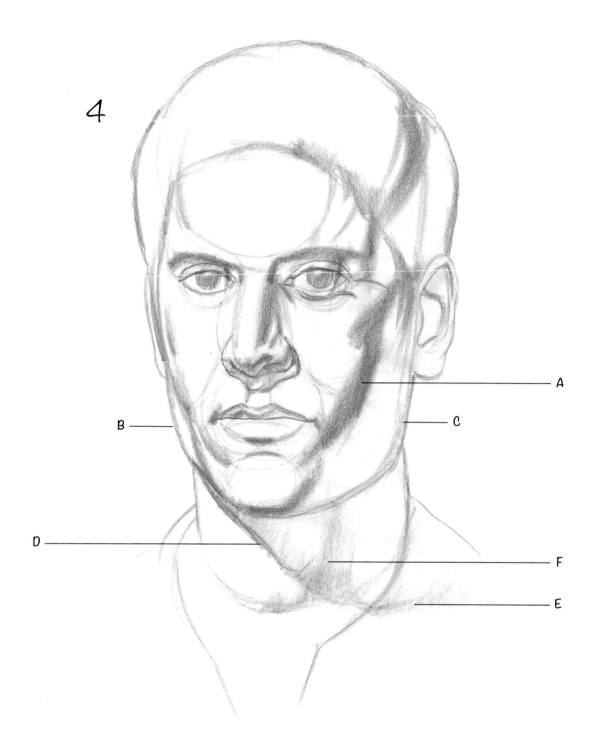

STAGE 4 EDGES AND OUTLINES Using the volumes as guides, draw the outlines and the core shadows. The core shadows are on the edges of the shadows (A). Core shadows give the forms corners and, hence, a three-dimensional quality. When drawing the outline, try to draw one side of the form (B) and then the other (C). You can do this with the jaw, cheekbones, nostrils, and so on. Sometimes, as on this nose, you must outline one side, then turn your pencil to the side and shade the core shadow. Keep the outline faint. By the end of the drawing you should shade up to it so that it no longer appears as a line. You must also draw the edges of the cast shadow (D). The edges aren't razor sharp, but they must be very clear—especially compared with the softness of the core. The shadow's edge will soften and lighten as it travels away from the form casting it (E). The shadow edge on the form is core (F); the edge thrown by the form is cast. Note your model's softest and sharpest shadow edges.

5

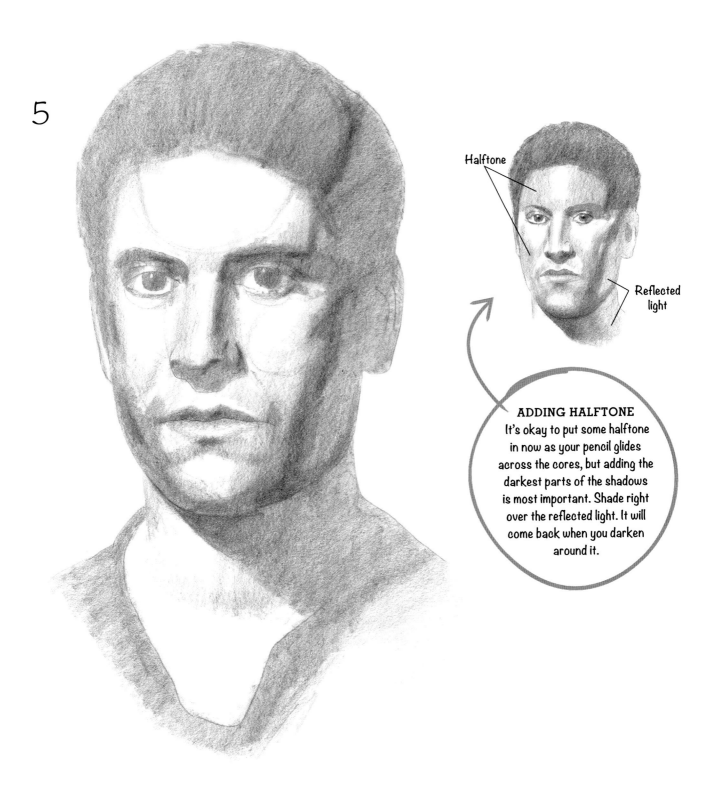

Halftone

Reflected light

ADDING HALFTONE
It's okay to put some halftone in now as your pencil glides across the cores, but adding the darkest parts of the shadows is most important. Shade right over the reflected light. It will come back when you darken around it.

STAGE 5 TONAL PATTERN This should be the simplest stage. Just squint your eyes, and the model's face will become blurry and simplify into a pattern of dark and light. The brain wants to exaggerate every tone (to show how clever it is), but if you draw only what the eye sees, your drawing will be more accurate. To judge tone correctly, you must squint often. This fresher eye will tell you when an area has fooled you into inaccuracy. If the model has a lot of shadow on his face, you can experiment with drawing this tonal pattern at earlier stages (though never before the lay-in and plumb line stages). A little toning is valuable to judge proportions and decide where to outline. Try to shade in one direction for the whole head (along or across the cores). Fill in gaps and shade evenly.

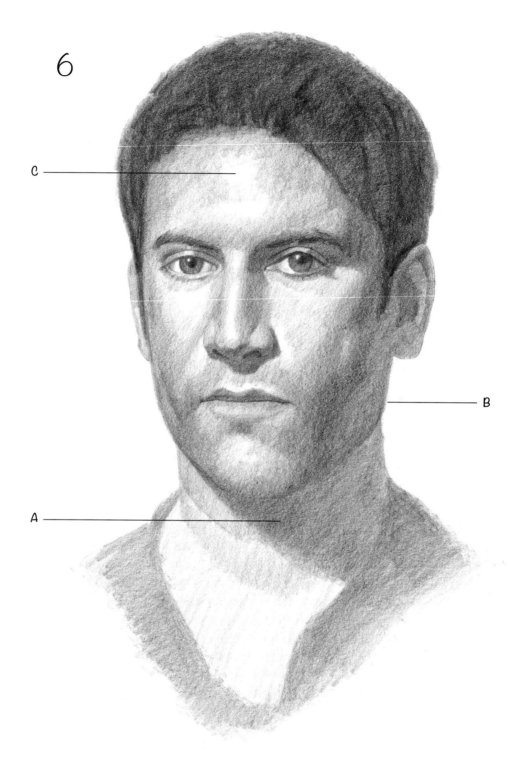

6

C ——————————

B ——————————

A ——————————

STAGE 6 FINISHING Always draw with a kneaded eraser in your opposite hand so you can continually clean up mistakes as you go along. Now focus on adding correct tone (value). This consists of adding darks and halftones. The darks must be gradually blended into the halftones by repeatedly caressing the side of the 9B into the "bed" of tone (A). Darks must be shaded up to any lines either on the outline or on the edges of the cast shadows (B). Caress halftones from the outlines or the core shadows all the way up to the highlights (C). Don't shade over the highlights, hoping to erase them out. This will result in flatness. By stopping at the highlight, a clear plane change emerges. Later you can, and should, rub over and erase them out, but first you must establish a clear division between the highlight plane and the halftone plane to avoid vagueness.

7

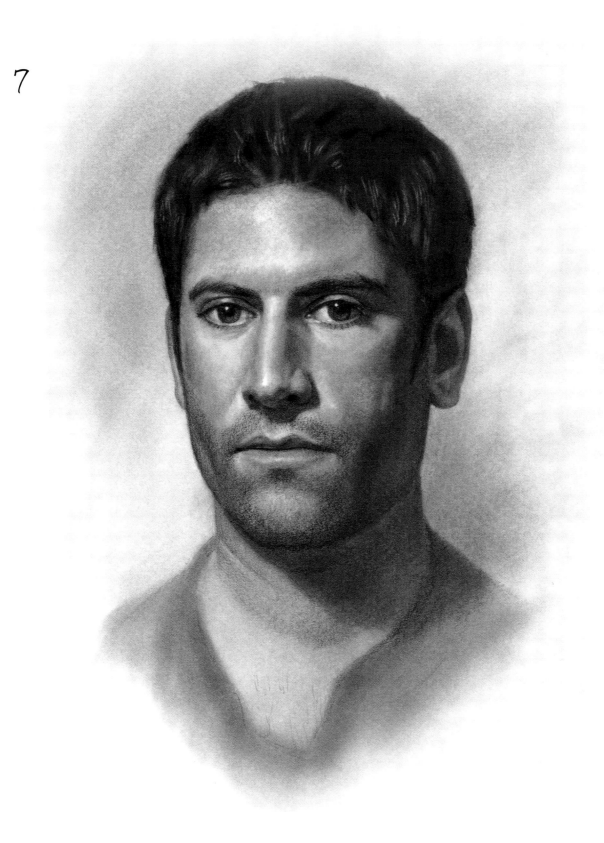

Scott Jeffrey, one day, life-size

STAGE 7 POLISHING As you stump, rub, and highlight, note that the head gradually darkens as it turns away from the highlight. Your blends should transition smoothly. Begin by using your stumps to rub the core shadows. Use the "cone" of the stump, not the tip. This smearing may change the tones, forcing you to reevaluate them. At stages like this, you may have to flatten your kneaded eraser and press it onto areas to lighten. Pull out highlights with your mechanical and battery erasers. Finally, drag a 9B over the chin and leave it rough to create stubble.

Young Woman

STAGE 1 THE LAY-IN First draw an oval with a 9B pencil. The straight-on view calls for a somewhat symmetrical shape, but don't worry about making the shape of the head accurate at this point; the oval simply is a tool to establish the size of the head. Mark the midpoint of the oval. Now you must find the midpoint on your model so you can place reference marks for nearby features, such as the eyes and brow ridge. Hold your pencil vertically with the pencil tip up. Extend your arm with your elbow locked, and place the pencil tip where you estimate the midpoint to be.

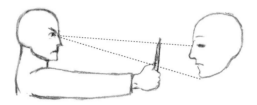

Then move your thumb along the pencil until the top of your thumbnail is in line with the model's chin. Now check yourself: Raise your arm so that the top of your thumbnail is at the estimated center. If the tip is now in line with the top of the model's head, then you've found the midpoint.

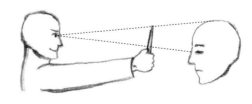

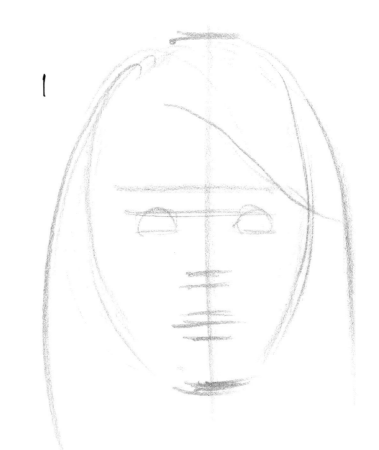

Now add a line to establish the vertical center of the oval; then estimate and check other vertical distances, marking the bottom, top, and center of the lips; the tip and base of the nose; the brow ridge; and the hairline.

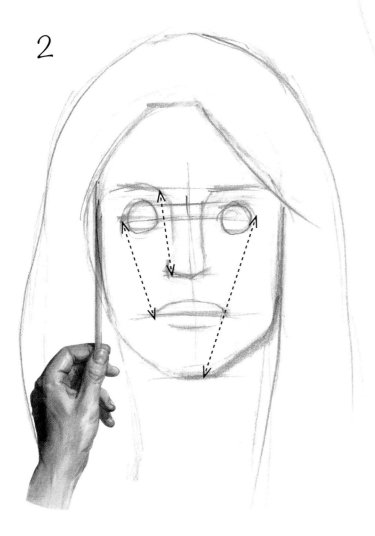

STAGE 2 PLUMB LINES Next nail down the placement of the facial features by checking your verticals, horizontals, and negative space. Begin by marking an estimated width for each horizontal line along the vertical line; then roughly block in the features. Compare the sizes of the features with one another, and continue to check the horizontal and vertical plumb lines, adjusting your drawing as necessary. As you draw, remember that the negative space between the forms is as important as the forms themselves, so compare the spaces in your drawing with your model often.

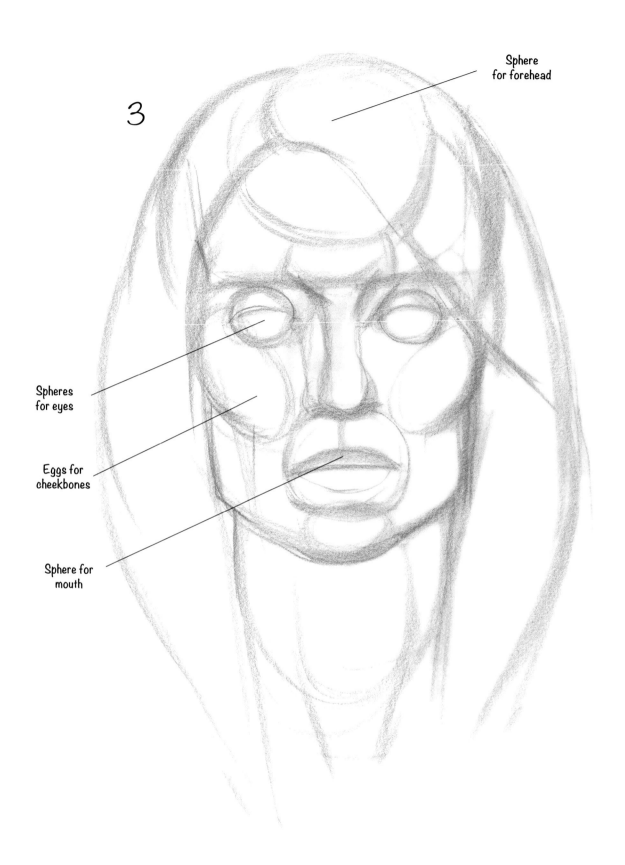

Sphere
for forehead

3

Spheres
for eyes

Eggs for
cheekbones

Sphere for
mouth

STAGE 3 VOLUMES Imagine simple forms that would fit inside the face under the surface. The forms will help guide you and the quality will emerge as you refine their shapes and tones. Using an underhand grip, start with the largest forms and draw the smaller ones into them. Represent the forms with basic volumes—spheres for eyes, eggs for cheekbones, and so on. Imagine that you are overlapping transparent forms, building up from larger to smaller forms.

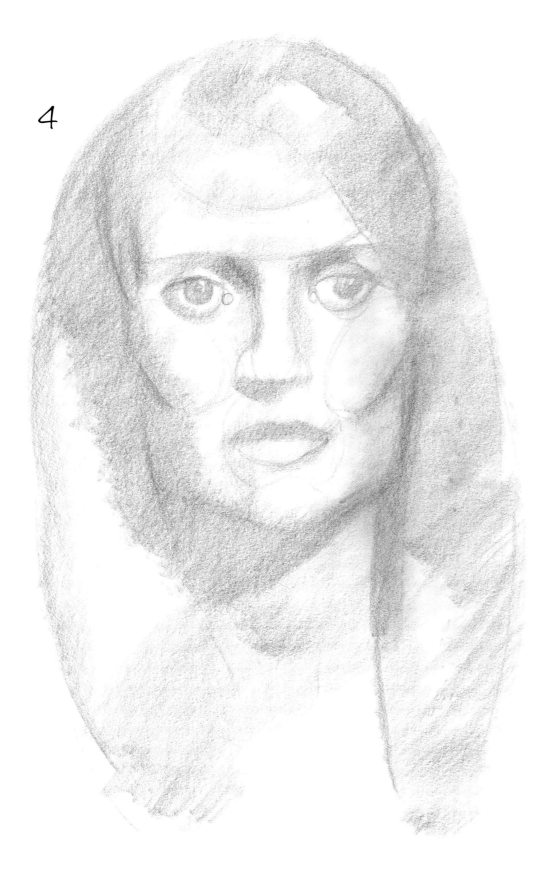

4

STAGE 4 TONAL PATTERN Look at your model and squint your eyes to see the face as a pattern of light and dark. The extreme highlights and darkest accents will blend into the main pattern. Now begin blocking in this pattern of tones on your paper, turning your pencil to the side and shading diagonally for quick coverage. Keep your strokes close together, and shade all the dark areas in the same direction to keep the drawing from appearing chaotic. (In more developed stages, one may shade in different directions when adding core shadows and dark accents.)

5

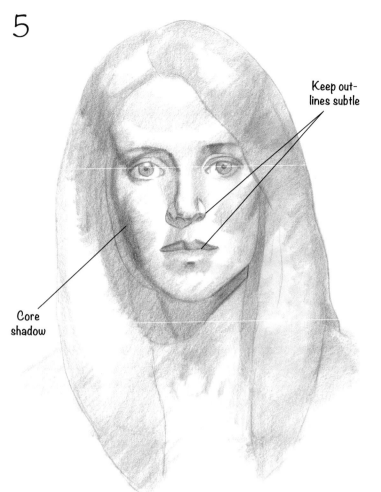

Keep out-
lines subtle

Core
shadow

STAGE 5 EDGES AND OUTLINES Every form on this model's face has a side plane, front plane, and sometimes a clear bottom plane. The softened corner where the planes meet is the core shadow. Turn your pencil to the side and shade a thick bar of tone—not a line—from her hair to her temple, around her cheekbone, and all the way to her chin. The core shadows overlap and soften where the forms soften. Don't ignore core shadows on the sides of the eyes or tip of the nose. As you add the core shadows, also add the subtle outlines. The outlines work like a parenthesis for each form. Try to outline one side of the form, then the other; then add the core and go back to the sides again—all in one operation. Now sharpen the edges of the cast shadows.

6

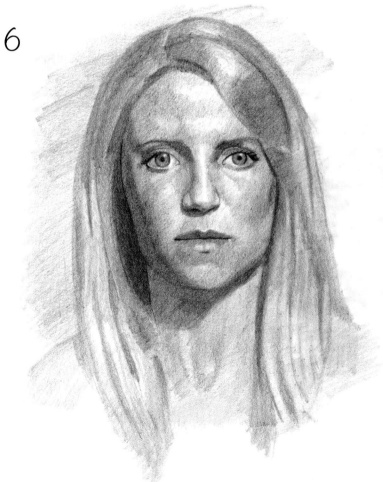

STAGE 6 FINISHING Now work within the new outlines to continue developing your shading. Lightly drag your pencil over the core shadows to pull halftone across them, diminishing the tone as it reaches the highlight. Notice how the halftones softly and gradually emerge from the core. They aren't isolated islands of tone; they mass against the core. As you shade, squint your eyes often to compare the relationships of tone on the model with those of your drawing. To make sure you're shading thoroughly, try holding a piece of white paper up to the model's face. With the exception of a few small white highlights, the entire face should have tone. Switch to a harder pencil, such as a 5B or 2B, and develop and darken details on the face.

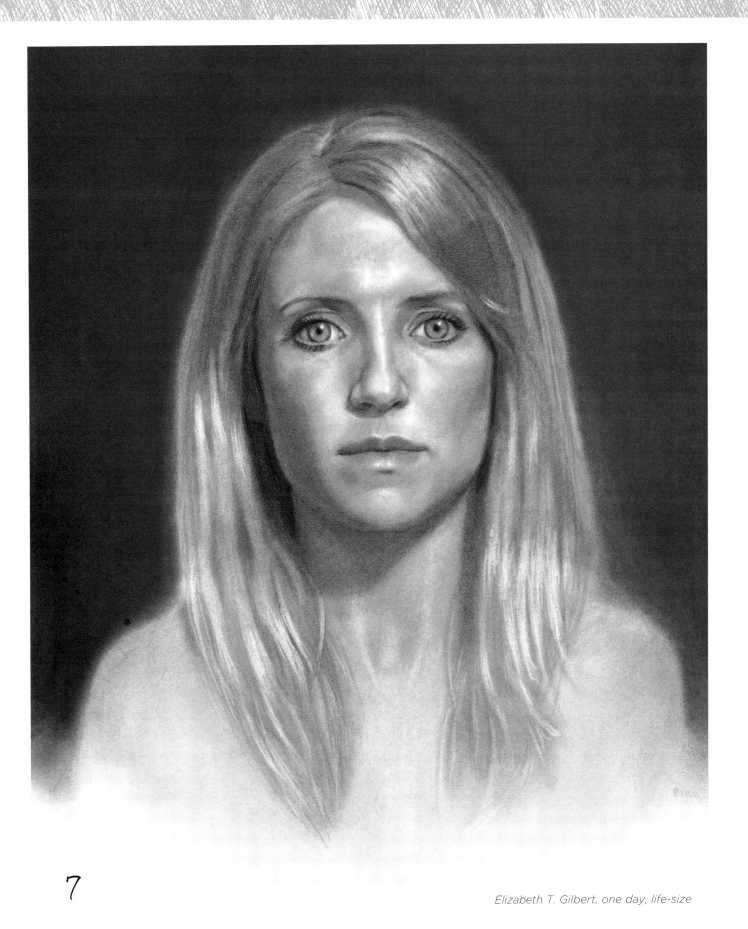

7

Elizabeth T. Gilbert, one day, life-size

STAGE 7 POLISHING Begin stumping the core shadows, and rub a makeup applicator over the dark details to soften and blend them. Burnish the entire drawing by caressing it with a powder puff, and then pull out the highlights with your kneaded eraser. If the highlights are too sharp, soften the edges with a clean stump. After burnishing, your drawing may lose a bit of value. In this case, simply go back in and re-introduce the darkest darks.

Girl

STAGE 1 **THE LAY-IN** Following the steps below, begin to build the form.

The face is slightly tilted, so draw an oval with an arced midline. Check the angle of the tilt against the 90-degree vertical of your pencil.

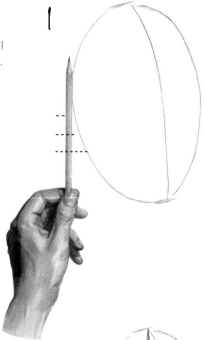

Measure the midpoint from top to bottom. With children, the proportions change every year, so rely on measurement rather than memorized rules.

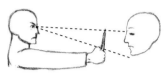

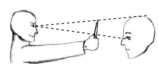

▶ Because a child's cranial mass is still larger than the face, the midpoint is not the tear ducts.

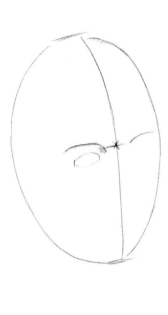

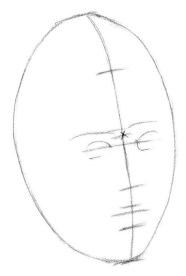

Guesstimate the distance of each form from top to bottom. Although it's natural to make slight adjustments up and down later, one should not be careless in placing these points. It's easy to adjust the widths of the forms, but lengthening and shortening forms requires a lot of erasing of adjacent forms.

STAGE 2 PLUMB LINES Now indicate the width of the head and check the horizontals. It's easiest to judge a tilted angle by placing a true horizontal below it (A). Next check the verticals and adjust as necessary (B); then check the spaces between the features (C).

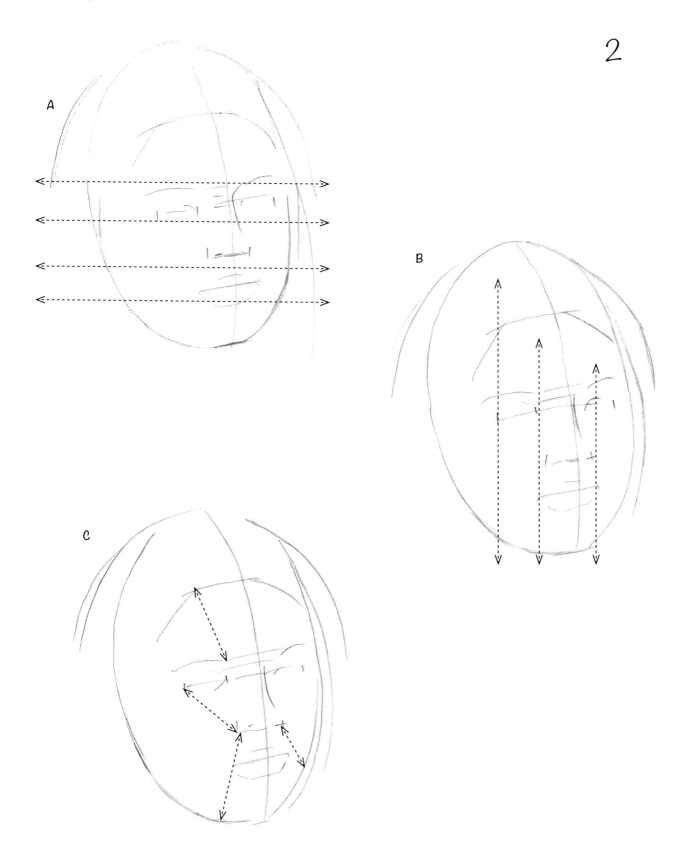

3

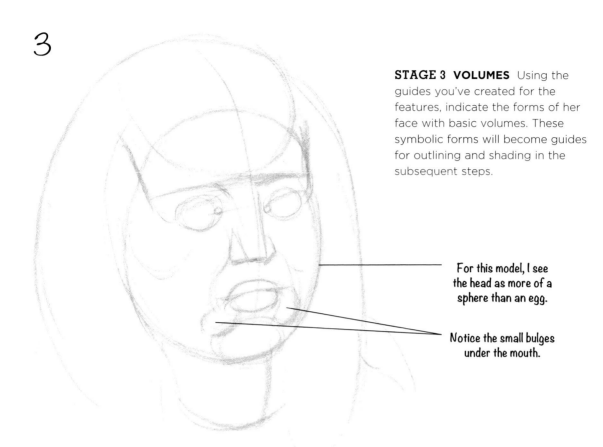

STAGE 3 VOLUMES Using the guides you've created for the features, indicate the forms of her face with basic volumes. These symbolic forms will become guides for outlining and shading in the subsequent steps.

For this model, I see the head as more of a sphere than an egg.

Notice the small bulges under the mouth.

4

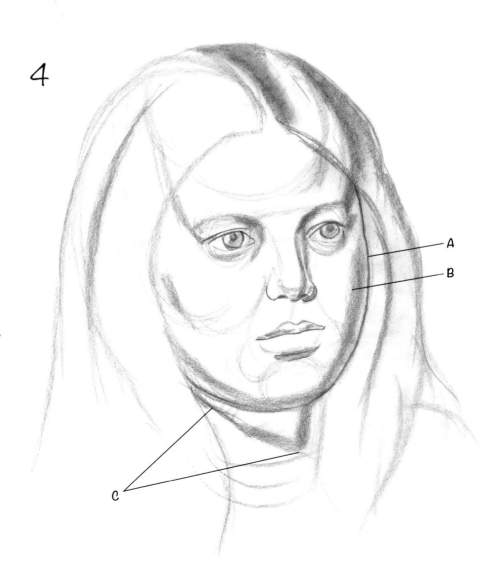

STAGE 4 EDGES AND OUTLINES
With this particular head, it's better to find the outlines before filling in the tonal pattern. Use soft outlines in most areas, but note that the outline can be dark if bordering a dark area (A). (Remember not to grind in the pencil until stage 5.) Now draw the core shadows with soft edges so they easily transition to the halftone (B). If the cores are drawn sharply, you'll have to work very hard to achieve a gradual turn of the form. Remember that cast shadow edges always start sharply and end softly (C).

A

B

C

5

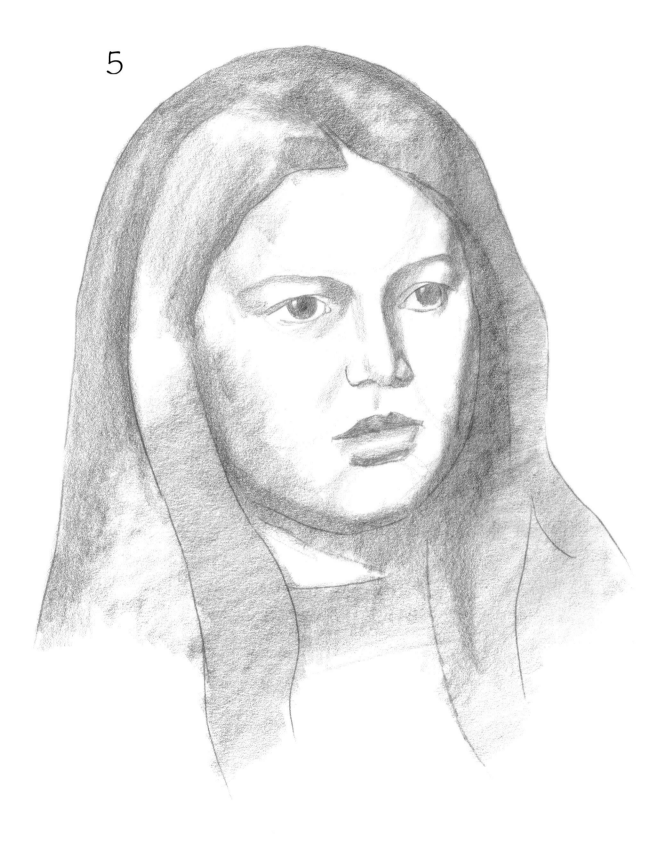

STAGE 5 TONAL PATTERN Try to shade over several forms with the same strokes to avoid a "pieced-together" quality.

6

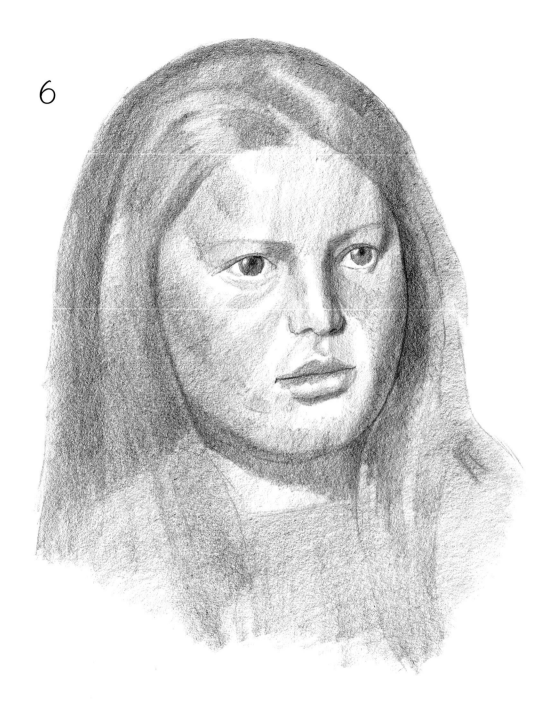

STAGE 6 FINISHING Add halftone, which should creep its way out from the shadow pattern, up to the highlights. Add all the darks, keeping in mind that nothing in the shadowed areas can be as light as anything in the direct light. Darken vigorously within the shadowed areas.

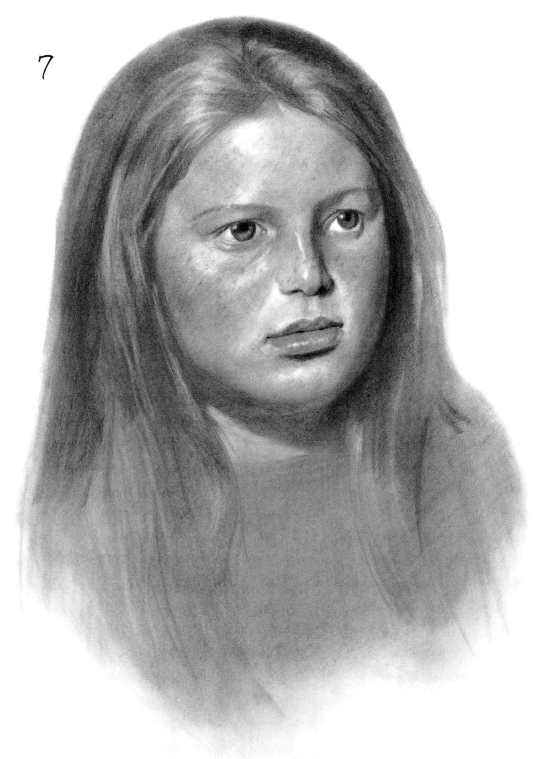

7

Celeste Davis, one day, life-size

STAGE 7 POLISHING To finish, go through the usual burnishing and picking out with the eraser. You can sharpen the battery-operated eraser for fine detail. Try to finish the hair in one sitting before the model needs to move because it will change. Add the freckles last. They should appear irregular and softly shaded with the side of the pencil—not as dots.

CHAPTER 4
OIL & ACRYLIC

Basic Techniques

It's helpful for artists to have a good eye, but having a few tricks or tools up your sleeve makes the job much easier. Accuracy is critical in portraiture, and these tips will help you achieve good proportions and flow throughout your painting. All you need are your hands and a long, thin brush.

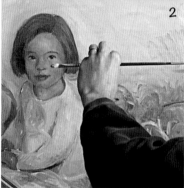

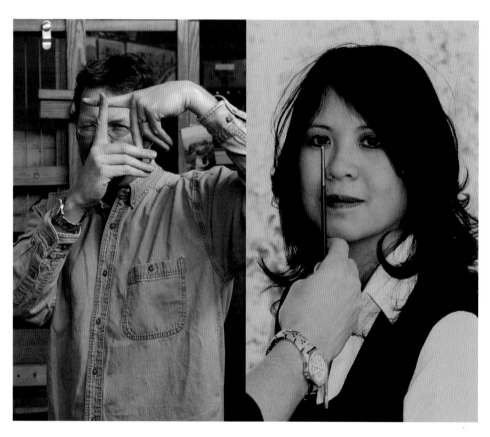

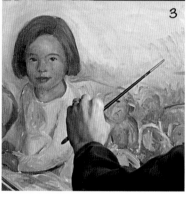

LOOKING AT YOUR COMPOSITION Look at your composition with one eye through your hands or a cutout before you begin painting. Move your hands or the cutout closer or farther from your eye to see exactly what you want to include in your painting. You'll quickly see what you find pleasing.

CHECKING MEASUREMENTS If you're painting life-size, measure the distance between the subject's eyes and chin, and mark it on the side of your canvas. Use this as a standard for proportion comparisons, such as the width of the face.

MEASURING WITH YOUR BRUSH Use your brush as a tool to check an object's deviation or relation to plumb or vertical lines (1), level or horizontal lines (2), and obliques or angles (3). By looking with one eye and holding your brush between you and your object, you can easily compare its shape to your painting.

USING MEDIUM Make sure to paint "fat over lean." The paint is "lean" and your medium (such as linseed or poppy oil) is "fat." This ensures quality adhesion of the paint to the support. If you enjoy using medium, save it for the top layers of your painting; don't use it as the foundational layer.

MIXING PALETTE Laying out your palette with tints of each color expedites your painting by its efficiency and promotion of quick decision making. It's also a great way to get warmed up before you begin the session. Mix color on your canvas as well as on your palette.

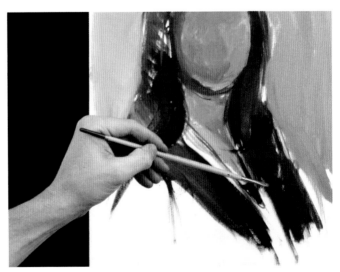

PAINT BIG Think in terms of dimension rather than details. For example, when painting the hair, think of it as a helmet rather than individual strands of hair. Then you'll be able to see and paint the larger planes and masses.

LONG-HANDLED BRUSHES Long-handled brushes facilitate working "large." Hold the brush at the end of the handle and paint as if you're a sword fighter: body turned, working deliberately yet delicately and precisely.

Portrait of a Boy

For this project, work out the composition in charcoal and then establish the color notes by painting spots of color in key areas, comparing one note against another. By using a palette knife and wiping it clean for each color spot, you can obtain clean, accurate color notes. Once the spots are in correct relation to each, you can move forward with confidence, establishing the large masses of light and shadow and refining them as you paint.

1 After toning the canvas with yellow ochre, lay in the portrait with vine charcoal, including only the necessary information. Then spray the drawing with fixative.

2 Thinking about large shapes, start with white and mixes of earth red and yellow ochre for the background.

PALETTE

- Burnt umber
- Cadmium red light
- Cadmium yellow
- Cadmium yellow light
- Caput mortuum violet
- Cerulean blue
- Earth red
- Ultramarine blue
- Umber
- Venetian red
- Violet
- Yellow ochre
- White

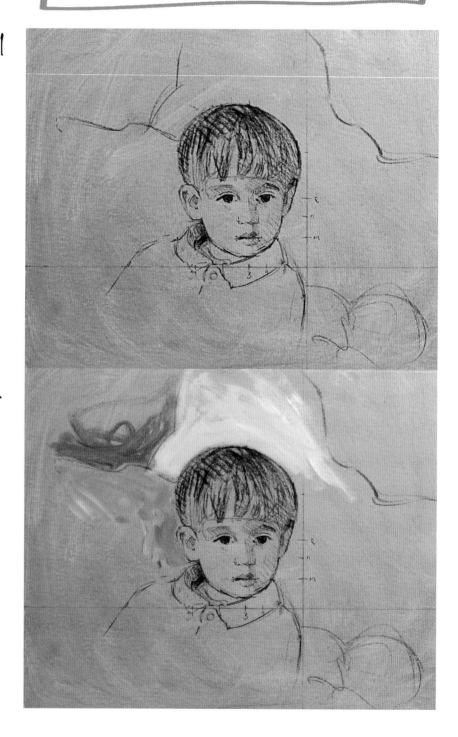

1

2

3 Begin to go after various color notes in the head and adjacent background, being bold rather than timid. Keep the notes separate and small so you can quickly adjust them as you compare one note against another.

4 When you're happy with the colors you've chosen, begin to lay in the painting. Paint the hair with burnt umber and earth red, keeping form in mind. Add burnt umber to the background at right and a mix of white with caput mortuum violet in the lower left area. For the pajamas, use a mix of white and a touch of cadmium yellow.

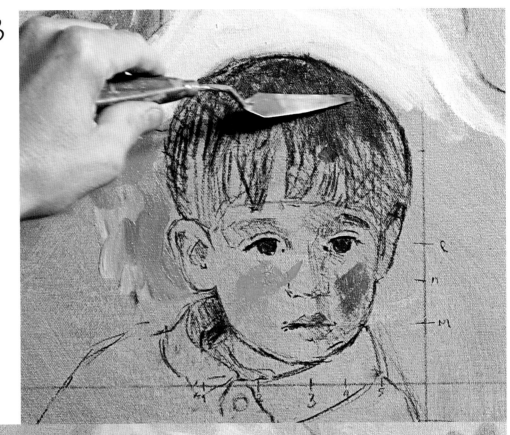

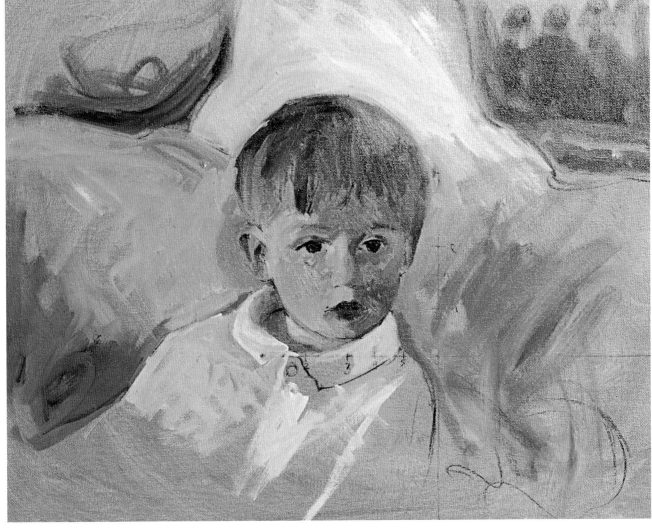

5 Focusing on value relationships, use these colors for the flesh: white, yellow ochre, and touches of Venetian red and cadmium red light (cheeks) for the lights. For the shadow side use yellow ochre, white, violet, Venetian red, and ultramarine blue.

6 Refine the face, add highlights to the hair (white and cadmium yellow light), and push back the background by reducing its contrast.

7 Add accents to the hair with umber and caput mortuum violet, and boldly introduce George (the monkey) with an earth red mix.

8 Use mostly yellow ochre, caput mortuum violet, cerulean blue, and white to develop and soften the background, which brings out Carter's face.

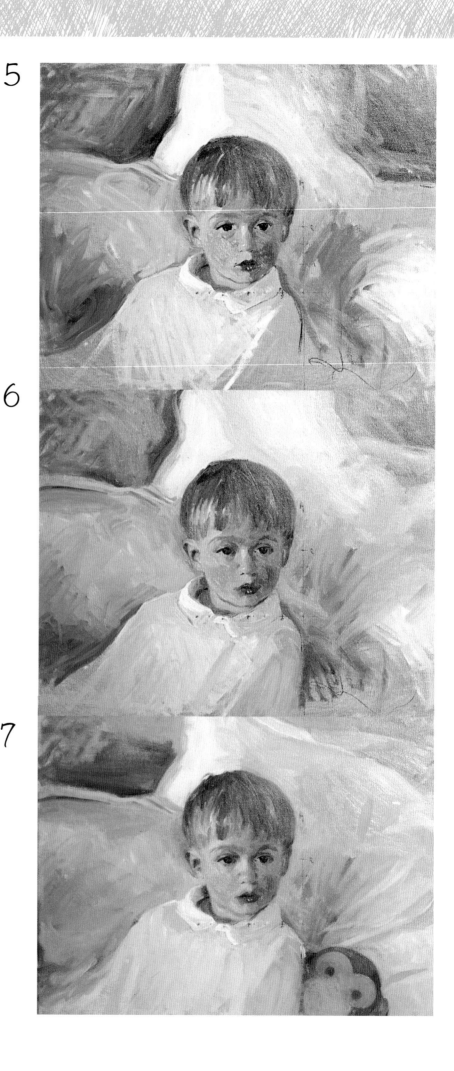

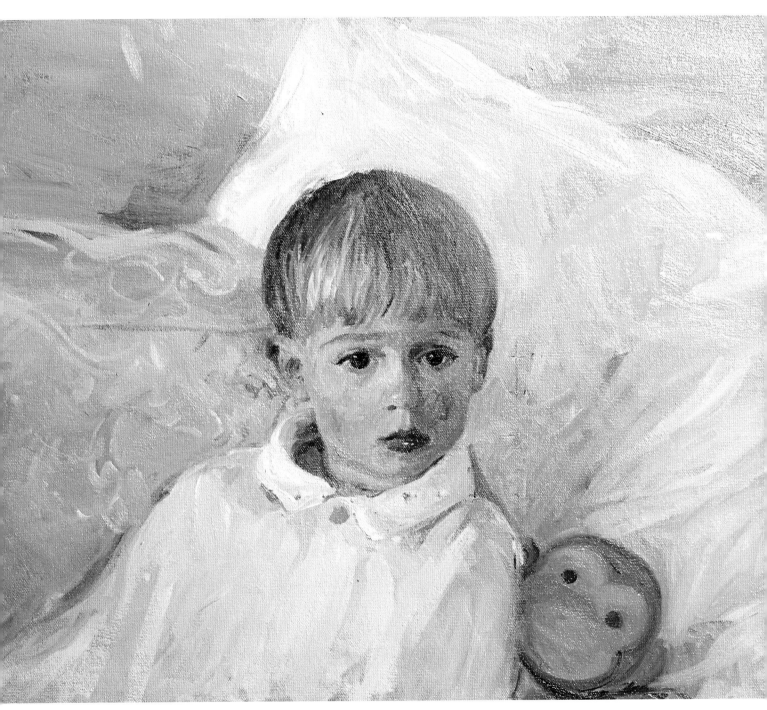

8

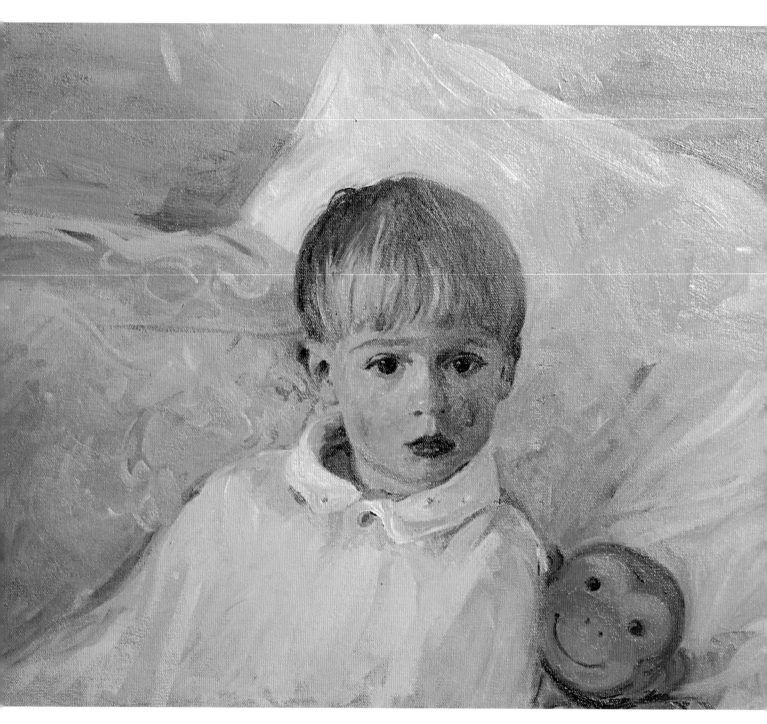

9 Continue refining the background and allow the initial tone to peek through in areas, but make sure to cover the charcoal sketch. Finish the monkey's face, keeping it simple.

9

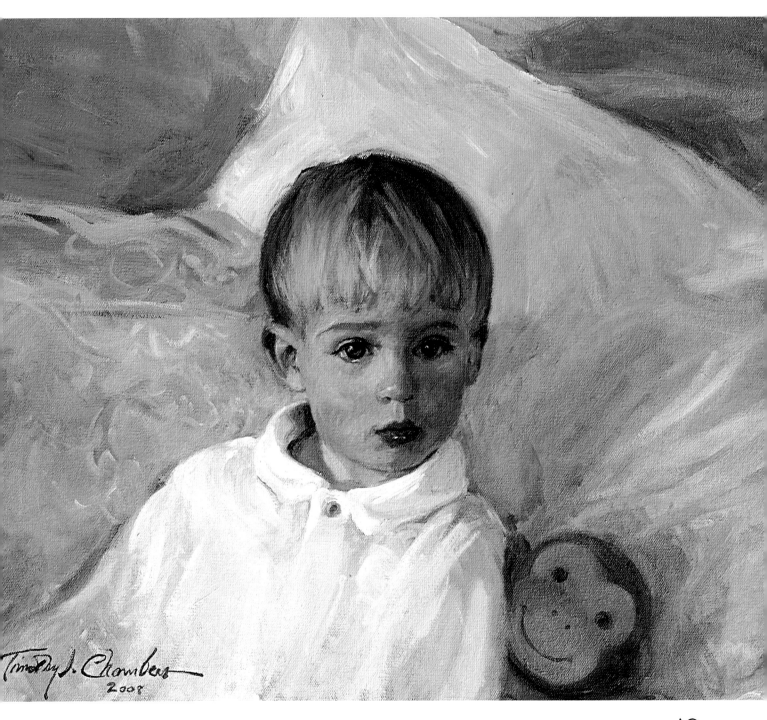

10 Refine the face, add highlights to the hair with white and cadmium yellow, and make the background recede using cool colors.

10

Painting from Photographs

PALETTE

- Bright red,
- Cadmium red light
- Caput mortuum violet
- Cerulean blue
- Orange
- Permanent rose
- Venetian red
- Yellow ochre
- White

1 After sketching the composition on paper, lay the foundation of the portrait on canvas using vine charcoal or a thin wash of paint. At this stage, try to be as vigorous and confident as possible, thinking about the larger shapes and not the features. Use guidelines that correspond with the reference photographs to ensure that the proportions are accurate.

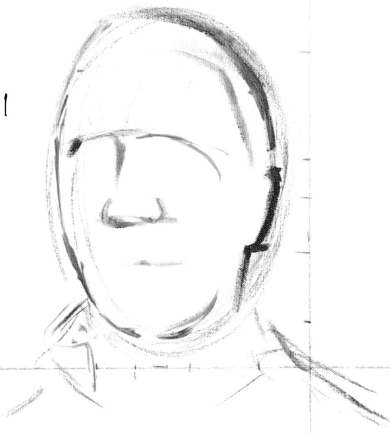

2

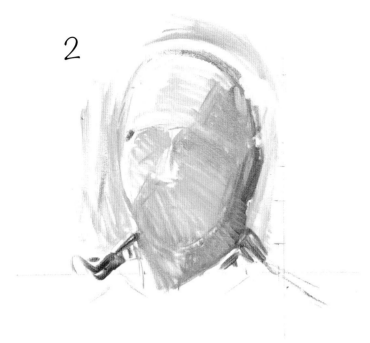

2 Once you're happy with the placement of the figure on the canvas, begin to lay in the color. Don't focus on filling in any particular area, but rather quickly establish the areas of light and shadow, as well as the background. This portrait is sized at 20″ x 16″.

3 Continue developing the color notes for comparison. Quickly place the location of the facial features, but not the details. Consider the form across the whole head, thinking of the skull's shape. From a distance, it's the skull that presents a likeness, not the eyelashes, nose, or lips.

3

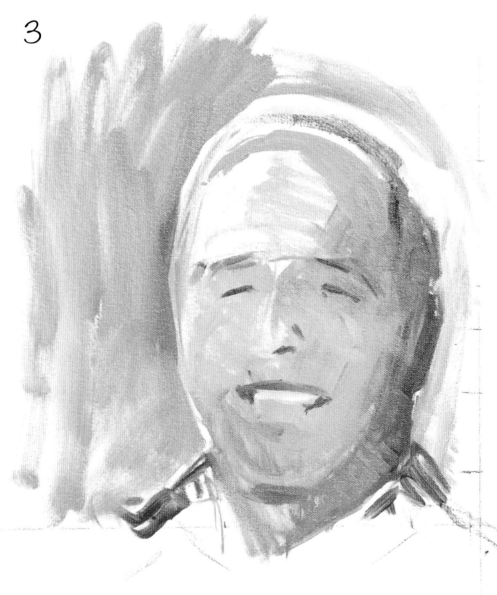

4 When you're comfortable with the relationship of the head to the canvas size, develop the skull by painting the large masses of light and shadow. Squinting often while you paint helps simplify the shapes so you can avoid getting sidetracked.

5 Keeping in mind the direction of the light source, begin to refine the colors, remembering that every color is relative to those that are adjacent.

6 Begin to unify the different values and shapes, such as in the forehead, keeping in mind the anatomical form of the skull underneath. You can see the distinction here between the colors for the highlights and those for the shadow planes. Use an array of paint colors.

4

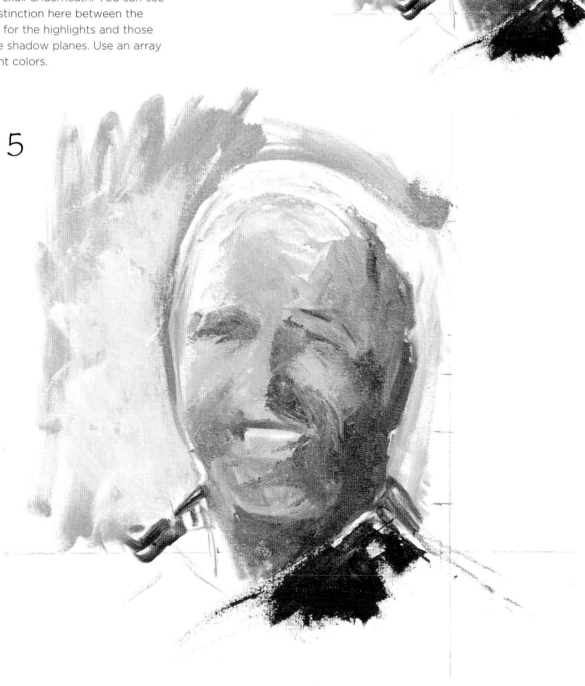

5

6

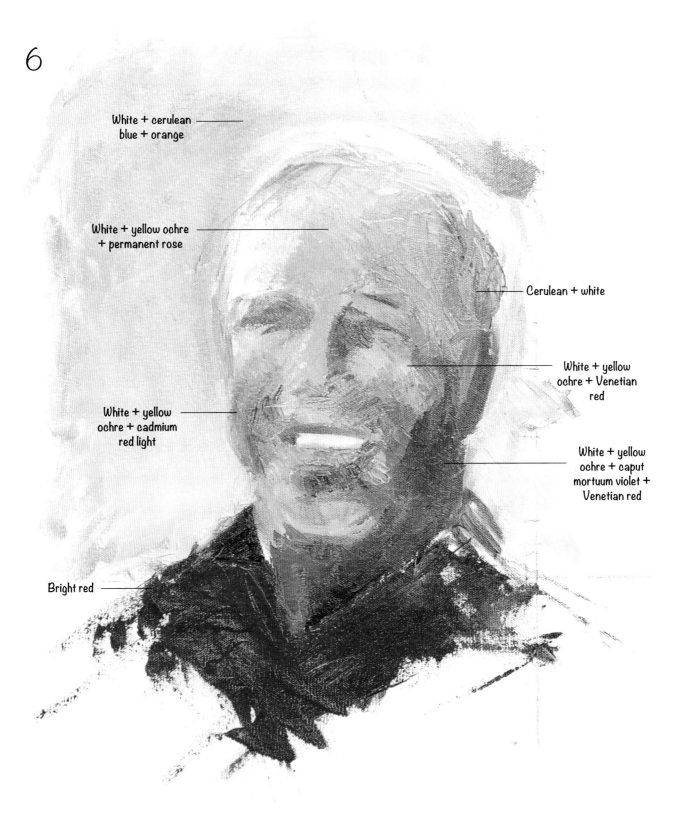

White + cerulean
blue + orange

White + yellow ochre
+ permanent rose

Cerulean + white

White + yellow
ochre + Venetian
red

White + yellow
ochre + cadmium
red light

White + yellow
ochre + caput
mortuum violet +
Venetian red

Bright red

7

8

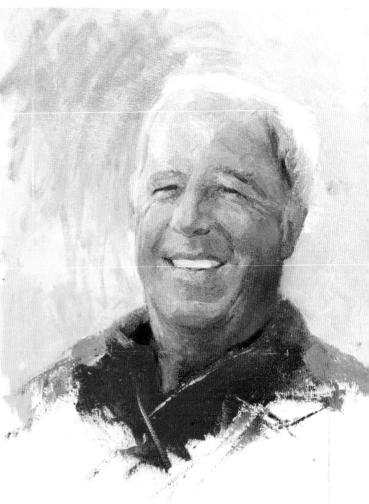

7 At this point begin to refine the features, but only enough to give them form. Continue to move across the entire face, developing the head as a whole.

8 Continue to refine the face, adjusting the values and noticing more of the characteristics of the features. The blue background is a bit cool, so warm it up a bit with some reds and yellows.

9 Alternately, you can completely change the background color to greens and yellows, creating more contrast and emphasizing the face. Don't be afraid to try a bold new direction if your painting isn't going where you'd like!

9

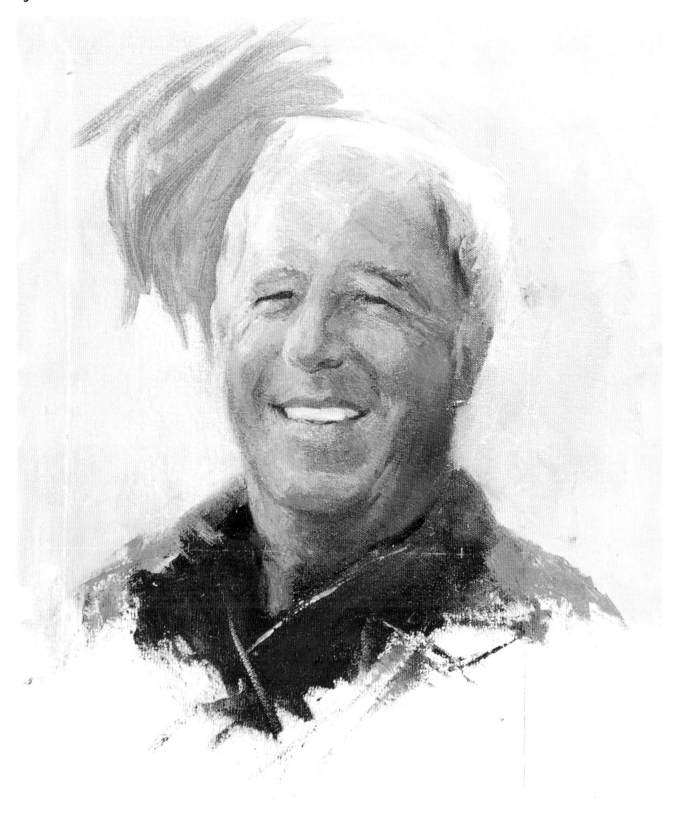

10

11

10 Continue to change the background, if desired.

11 Finish adding color to Ed's shirt, touch up his hair, and round out his forehead. Continue moving around the portrait, never getting stuck in one place.

12 Most of the energy in many portraits exists at the first and last stages of the painting. In the beginning, you quickly move from a plain white canvas to something with color and dimension. The middle stage requires much focus and perseverance as you work out the composition, color, and objects. Once these are settled, the excitement ramps up again as you head down the final stretch, where you add the highlights, dark accents, small details (such as wisps of hair) and lost and found edges. Walk away from the portrait for a little while to get a fresh look when you return. If anything jumps out at you, correct it.

12

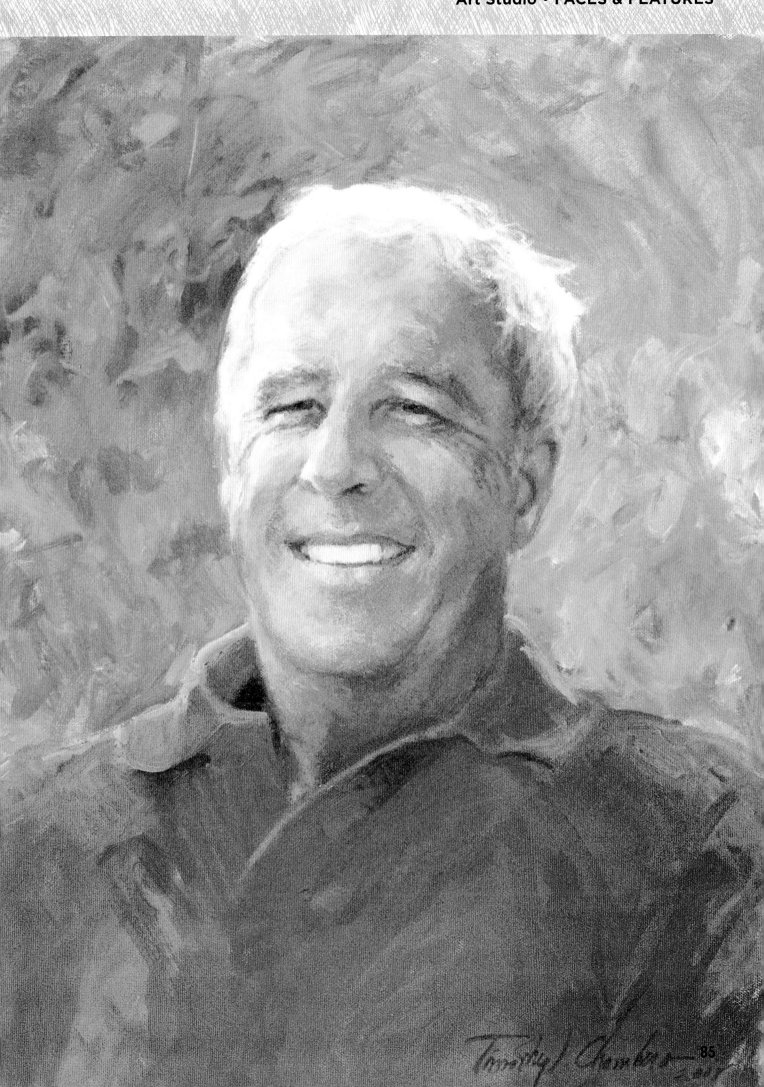

Painting from Life

Nothing takes the place of painting from life. For this portrait, the light is set at a 45-degree angle. Painting from life is a moment-by-moment learning experience. Study the facial features and the body and really get to know your model.

PALETTE

- Alizarin crimson
- Burnt sienna
- Cadmium red
- Cadmium red light
- Cerulean blue
- Perylene red
- Titanium white
- Transparent red oxide
- Ultramarine blue,
- Viridian green
- Yellow ochre

1 Start by blocking in the values, using ultramarine blue and burnt sienna mixed with a bit of turpentine. Look for the masses of dark, middle, and light values. Don't try to create an exact image, but paint in an abstract form. Wipe off any excess paint with a soft cloth.

2

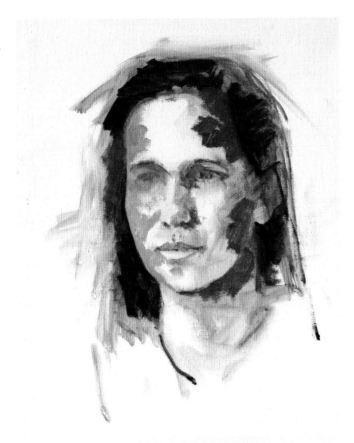

2 Next start mixing yellow ochre and cadmium red with titanium white, creating different piles of skin tone colors. Add burnt sienna and a little viridian green to some piles for darker tones, and begin painting in the skin values on the face and blocking in the dark hair.

3 Continue painting the face, keeping the edges soft to allow for any necessary adjustments. Soften any noticeable hard edges by gently swiping them with a soft, clean brush.

3

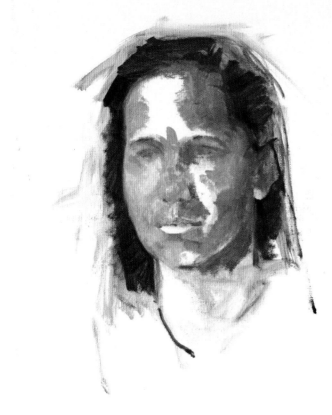

4 Begin blending the lights and darks to create form and smooth skin texture. Mix titanium white, cadmium red light, yellow ochre, and a touch of transparent red oxide for the cheeks, nose, and ears. Cheeks are usually slightly rosy, but cooler in color than the nose or ears. To slightly gray the mix for the cheeks, Add viridian green. When painting dark hair or eyes, start with a mixed brown that you can adjust to be lighter or darker as needed. Start the eyes with a brown mix of ultramarine blue, transparent red oxide, and alizarin crimson.

5 Start blocking in the dark hair with the same mix you used on the eyes. Then lighten the mixture with yellow ochre, a touch of cadmium red light, and cerulean blue to paint lighter values in the hair. Add a few very light strokes with a mix of yellow ochre and a bit of titanium white. To get the greenish-amber color of the iris, mix yellow ochre and viridian green. Add a bit of the original brown eye mixture. Then paint the whites of the eyes, using cerulean blue mixed with cadmium red light and a touch of titanium white. Add a couple pure white highlights. Create a rough background with broad strokes of yellow ochre mixed with titanium white.

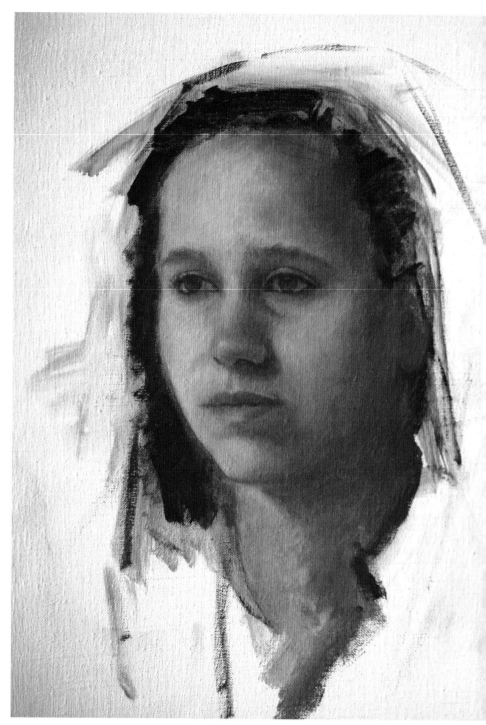

4

As you work on each area, constantly return to other areas of the painting to adjust darks, lights, cools, warms, etc. Painting is a never-ending battle for balance, and there is always room for improvement.

5

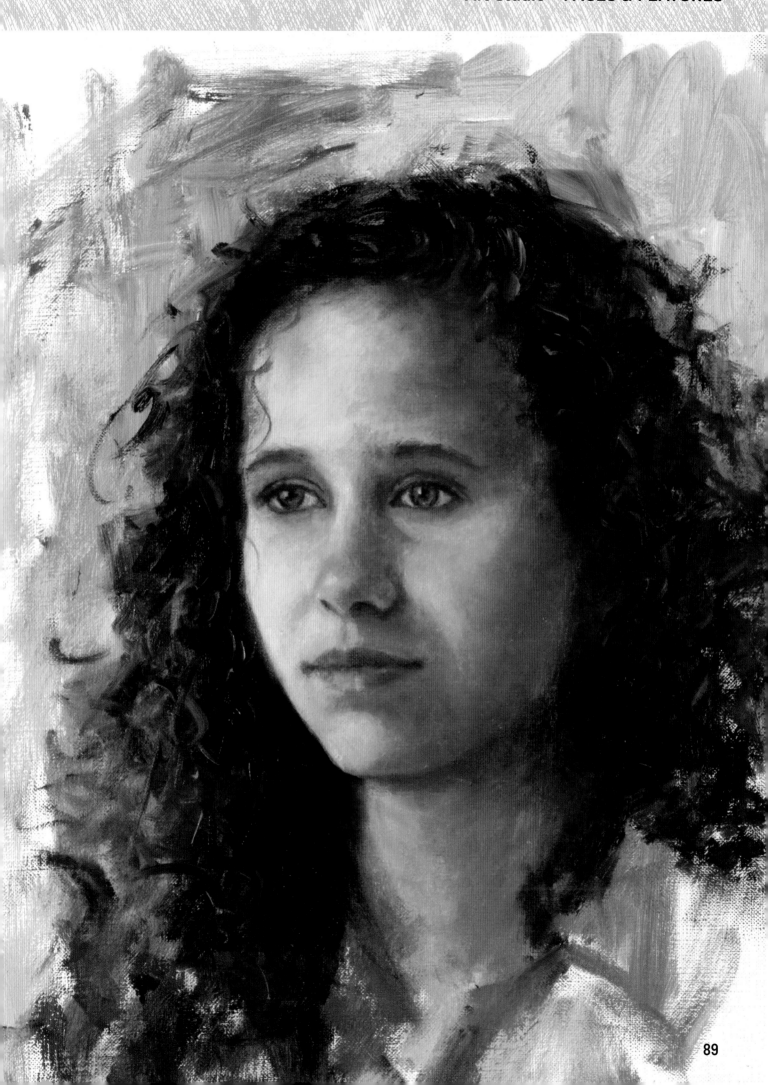

WATERCOLOR

Young Girl

PALETTE

- Burnt sienna
- cerulean blue
- French ultramarine blue
- Green gold
- Hooker's green dark
- Permanent rose
- Quinacridone magenta
- Quinacridone violet
- Raw sienna
- Scarlet pyrrol
- Sepia
- Titanium white
- Viridian green

1 Draw the image on watercolor paper, and add liquid frisket in the highlight areas of her hair, eyes, lips, and shirt ruffle.

2 With a 2″ flat brush, wet the entire face and arms and add a light mixture of raw sienna and permanent rose. Wet the darker area of her hair and drop in burnt sienna, sepia, and raw sienna. Let these colors mingle, and soften the edges with a medium round brush before the paint dries. Once dry, rub off the frisket from her eyes and hair. Paint her shirt with a watery layer of permanent rose.

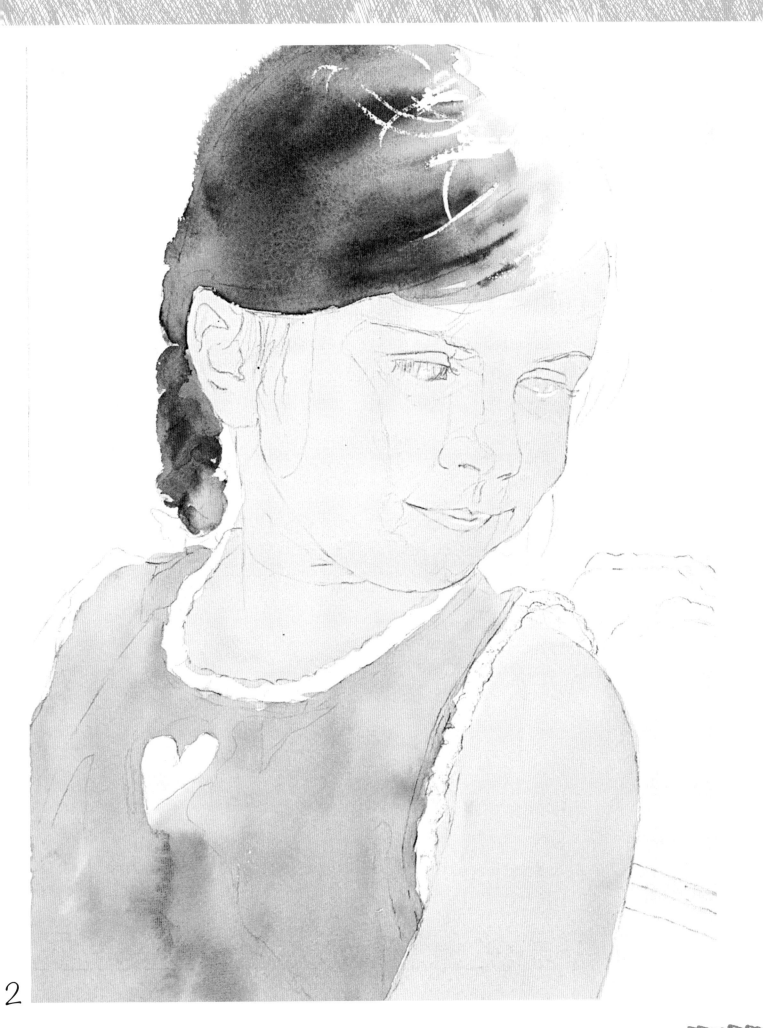

2

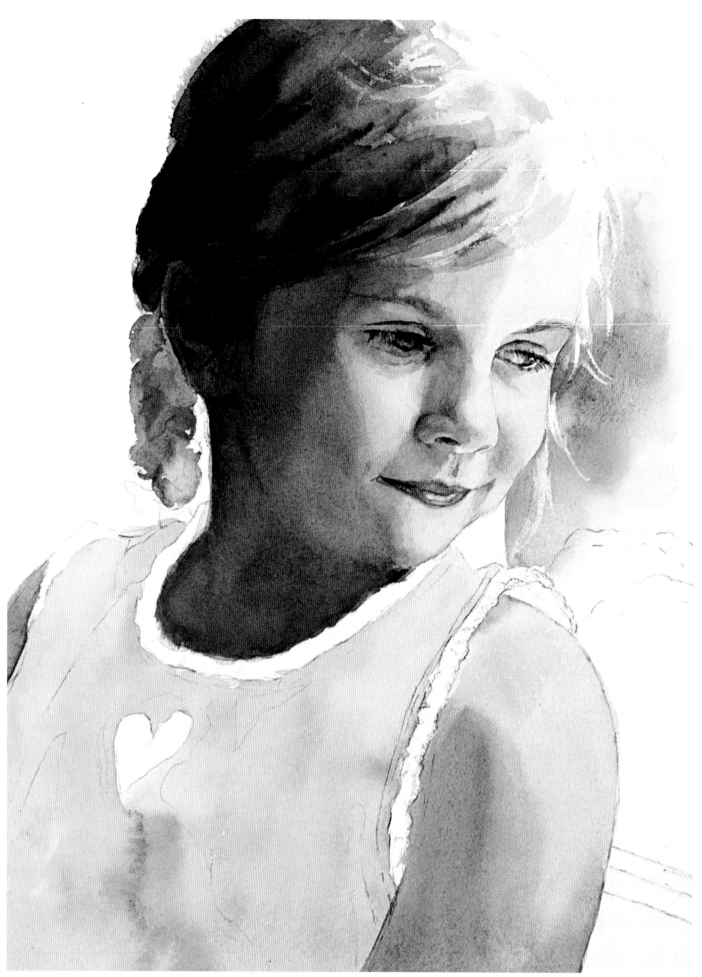

3

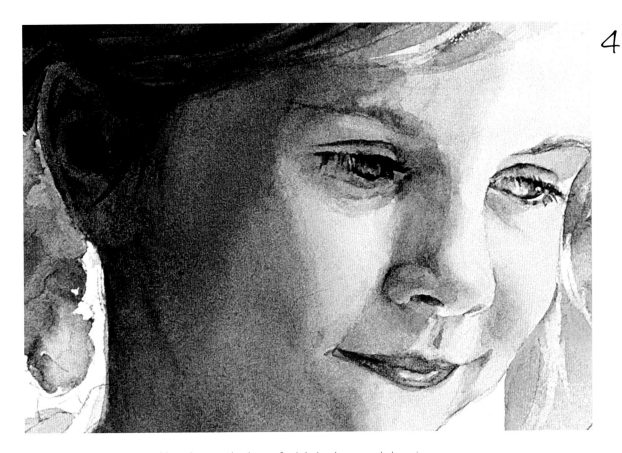

4

3 Using a medium round brush, wet the large facial shadows and drop in French ultramarine blue, raw sienna, and permanent rose, taking care not to leave hard edges. Add a watery mixture of permanent rose, raw sienna, and French ultramarine blue to define the shadows on the light side of her face and above her upper lip. Darken her hair with sepia and burnt sienna, softening the edges with a damp medium round brush. To compare the values of the background and skin tones, wet a small section next to her face and drop in viridian green and raw sienna.

4 With a medium round brush, add scarlet pyrrol to her cheeks and nostrils. Switch to a small round brush and paint her lips using permanent rose. Wet the irises and drop in cerulean blue and raw sienna, adding small dabs of French ultramarine blue to the outer edges. Paint the eyelashes with a mixture of French ultramarine blue and sepia, then define the eyelids. Paint the shadows of her ear with a mix of French ultramarine blue and quinacridone violet, keeping the edges soft and blurry. Once dry, remove the frisket from the facial highlights.

5

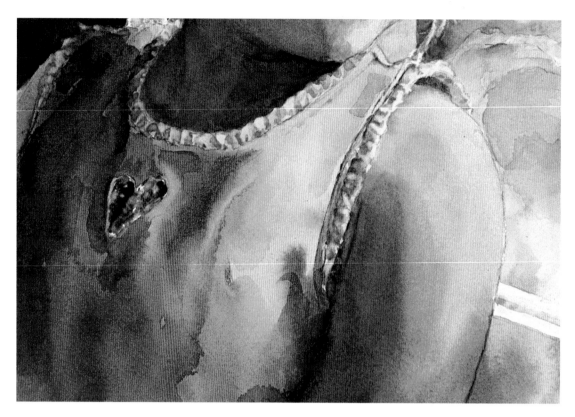

5 Add another wash of permanent rose to her shirt. Concentrate pigment in the shadow areas and add quinacridone violet to darken. For the ruffle, add a wash of viridian green and green gold. Then remove the frisket and wet each shadow area, dropping in various concentrated mixtures of green gold, viridian green, Hooker's green dark, and cerulean blue. Wet the heart shape and wait for it to become only slightly damp before dropping in permanent rose, scarlet pyrrol, cerulean blue, quinacridone violet, and Hooker's green dark.

6 With a 2″ flat brush, add washes of quinacridone violet on the left. Follow with French ultramarine blue in the darker areas. Add a few brushstrokes of titanium white to break up the purple. For the window scene, wet the entire area and randomly drop in your greens and raw sienna. Switch to a medium round brush and loosely paint her reflection using the colors from her shirt and skin tones. Paint the window frame with a watery mix of quinacridone violet, raw sienna, and permanent rose. Finally, use a nearly dry, extra small round brush to paint wisps of hair in titanium white.

> Think about details and why you are including them. In this painting, the ruffles of the blouse create rhythm and repetition, while the rest of the shirt is painted in a loose manner.

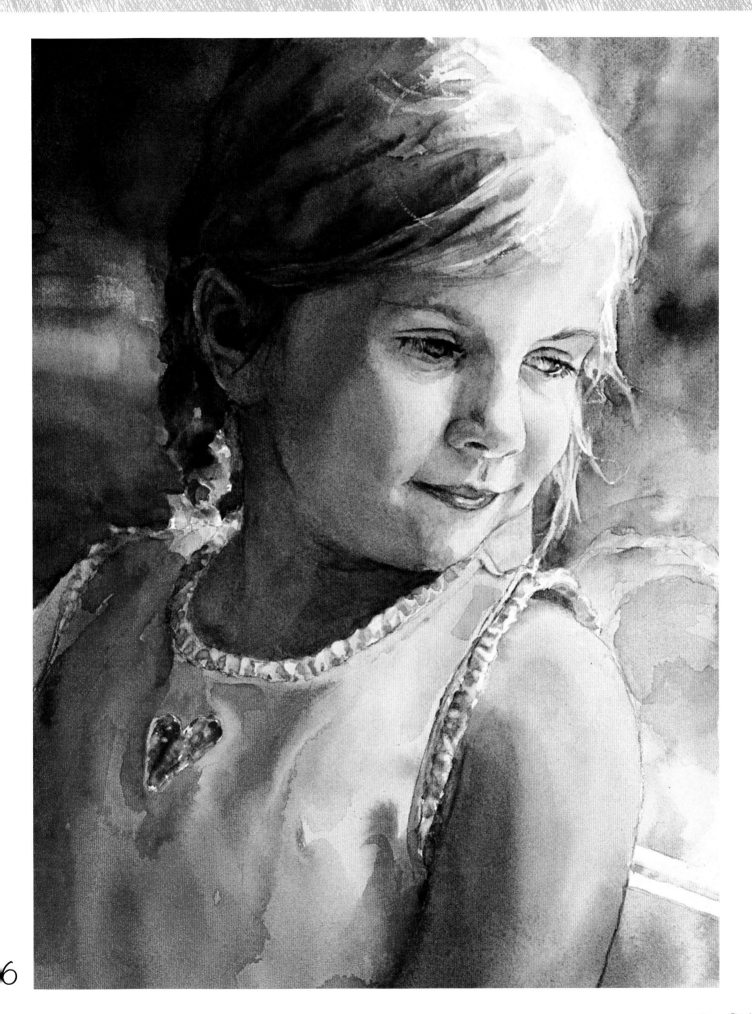

Working with Bold Patterns

This painting incorporates a bold, graphic background with a central figure. The challenge is to balance the patterned background with the prominence of the figure in the foreground.

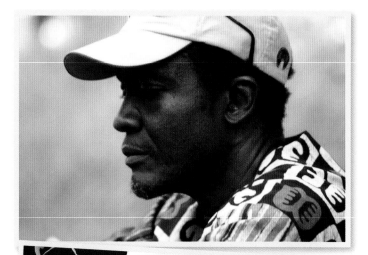

PALETTE

- Burnt sienna
- Cerulean blue
- French ultramarine blue
- Permanent rose
- Quinacridone magenta
- Raw sienna
- Sepia
- Titanium white
- Viridian green

The pattern on this man's clothing represents his West African heritage, but by itself, this might not be a very interesting portrait. The unique background to the left (bottom), added digitally, is more compelling.

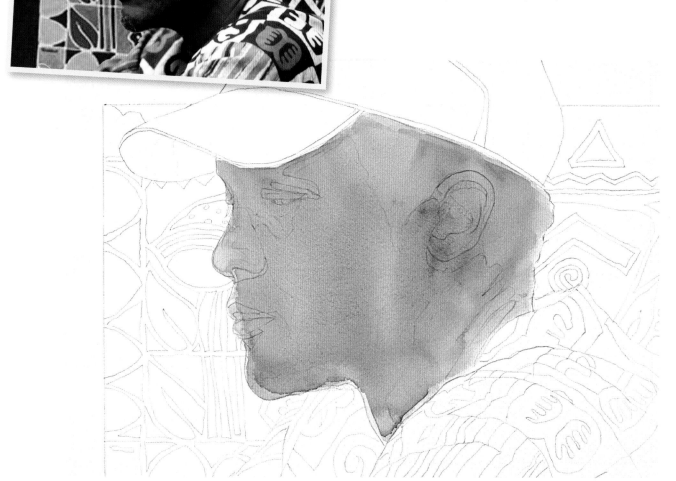

2

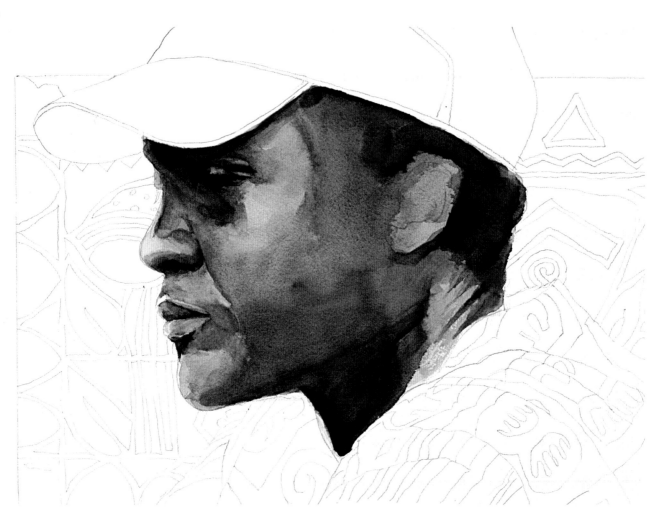

1 Transfer your sketch to watercolor paper and include as much detail as you can. Using a large 2" brush, start with water only and then drop in a mixture of burnt sienna and viridian green over his face and hair. Match this value to the lightest area of his skin.

2 Wet the shadow area under the brim and along the edge of his hat with a large round brush. Then drop in concentrated mixtures of viridian green, French ultramarine blue, sepia, and burnt sienna. Add extra cerulean blue to cooler areas and viridian green and burnt sienna to warmer ones. Roughly define the eyes and nose with a mix of sepia, French ultramarine blue, and burnt sienna and the mouth with a wash of French ultramarine blue and quinacridone magenta. Don't add any detail at this point.

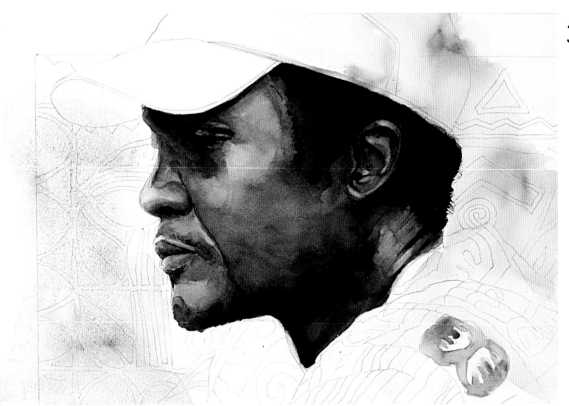

3 To add definition to his face, increase contrast in the shadow areas using a concentrated mix of sepia and French ultramarine blue. Apply color along the jawline, in the shadow along the cap, in his hair, and under his nose and ear. Define the shape of the eye on the right and let the color bleed into the shadow.

4 Paint each background shape separately by wetting the area and dropping in one of the following: raw sienna; sepia; a mixture of raw sienna and burnt sienna; or a very light mixture of sepia and raw sienna. The background colors need to be slightly lighter and have less contrast than the figure.

5 Wet the entire area of the hat and lightly drop in a watered-down mix of raw sienna, cerulean blue, and sepia. Add more sepia to the shadow area under the brim. Darken select background shapes with another wash of color.

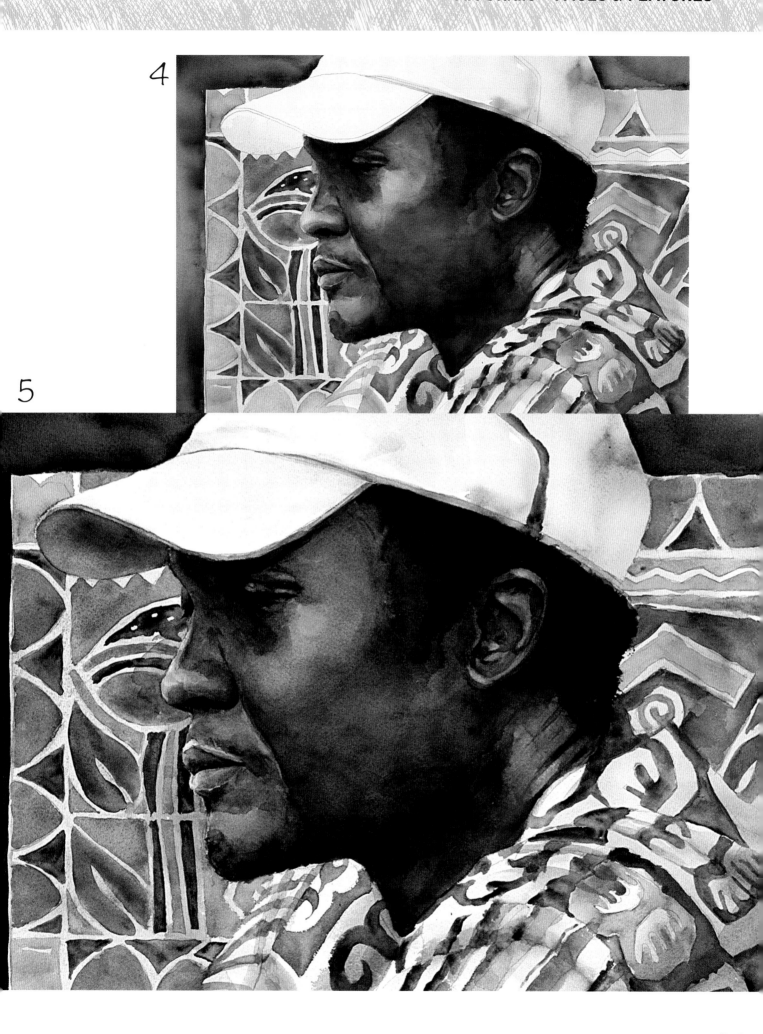

Expressive Lighting

Different combinations and positions of light can lead to interesting surprises. In this painting, the challenge is to recognize and capture the warm and cool temperatures created by the contrasting lighting. Lights above and behind the model create a strong backlight with warm highlights and cool shadows. A window to the right provides additional light with cool highlights and warm shadows.

PALETTE

- Burnt sienna,
- French ultramarine blue
- Manganese blue
- Quinacridone rose
- Quinacridone violet
- Raw sienna
- Scarlet pyrrol
- Sepia
- Titanium white
- Viridian green

1 You can make changes to any photo to create a stronger composition. Here the image is flipped and cropped to a horizontal format. Draw the image on watercolor paper.

2 Using a large 2″ brush, add a watery mixture of raw sienna, quinacridone rose, and a touch of burnt sienna. Add more pigment to her chin, where the light is strongest.

3 Switching between a 2″ flat brush and a medium round brush, wet the entire shadow area of her skin and quickly drop in French ultramarine blue, quinacridone violet, quinacridone rose, and raw sienna. Let the colors mingle and dry.

2

3

4

4 Add liquid frisket to her hair before starting the background, which will take several layers. To create a misty look, drop in titanium white while the paper is wet. Add quinacridone violet, sepia, French ultramarine blue, and manganese blue. Mix sepia and French ultramarine blue for the darkest area of her hair.

5

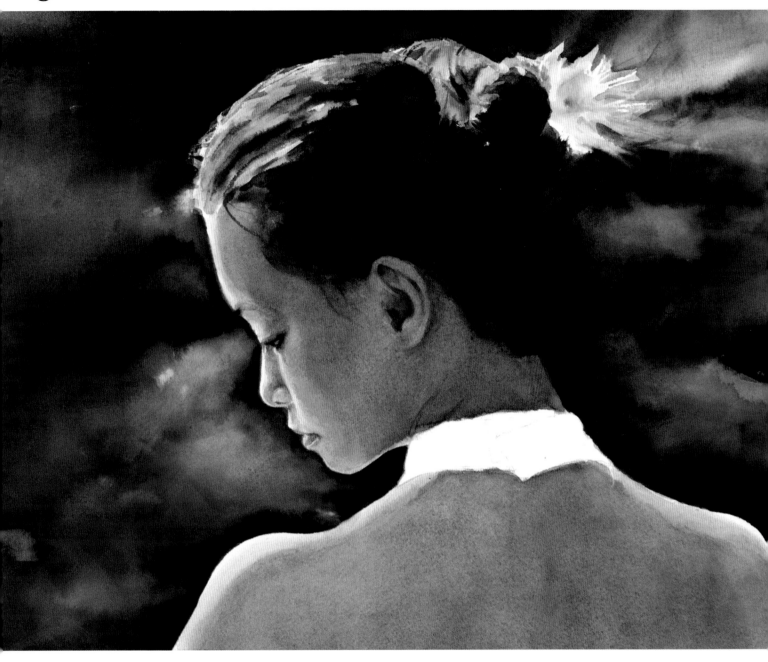

5 Using a large round brush, continue to darken the background. Add more sepia, manganese blue, and French ultramarine blue. Add a layer of titanium white and swirl it around with the tip of the brush. Remove the frisket and paint the warm highlights of her hair with scarlet pyrrol, raw sienna, manganese blue, and quinacridone violet, softening the edges. Finish the cooler, darker areas of her hair with sepia and French ultramarine blue and blend the outside edge into the background.

FACIAL DETAIL Paint her eye with several simple strokes of sepia and French ultramarine blue using a small round brush. Add scarlet pyrrol to her nostrils and scarlet pyrrol and quinacridone violet to her lips. Paint her eyebrow with one stroke using a very watery sepia. Drop in more sepia on her brow in the darkest area. Paint her ear with a mixture of quinacridone violet, sepia, quinacridone rose, and raw sienna.

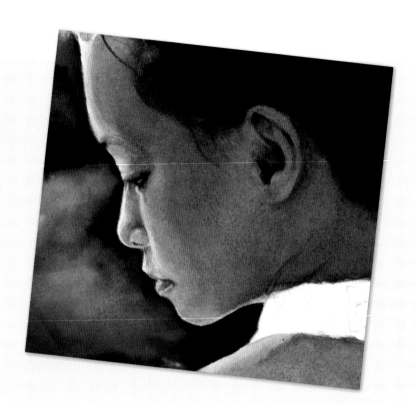

HAIR DETAIL Use an extra small round brush to paint the wispy, backlit hairs. Load the brush with titanium white and mix it with raw sienna or manganese blue. For the wispy hairs around her face, use a watery mixture of sepia and French ultramarine blue.

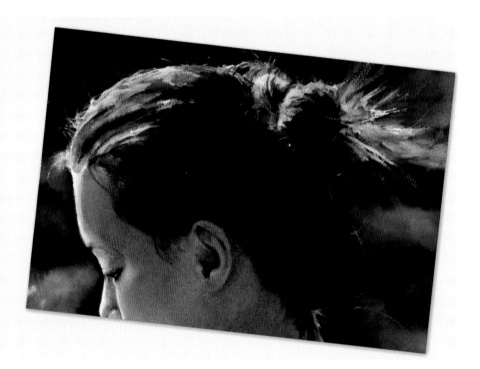

To soften skin tones, mix titanium white with your established skin colors and lightly brush over the area. Use a 50/50 ratio of water to pigment.

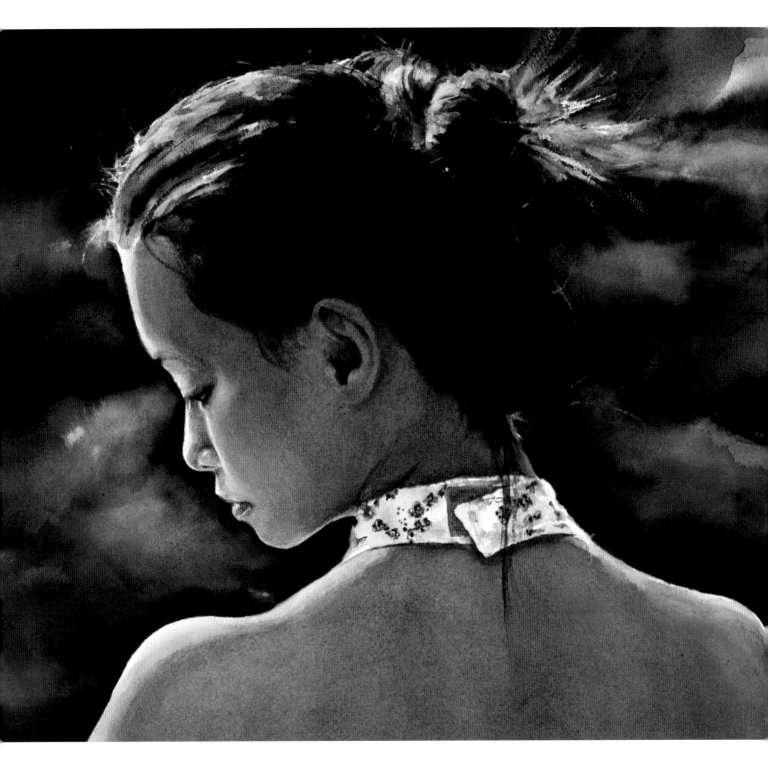

6 Using quinacridone violet, scarlet pyrrol, and quinacridone rose, paint her satin collar by wetting each shape and lightly dropping in the color. Add a shadow underneath with a watery mixture of French ultramarine blue and quinacridone violet. Once dry, add a wisp of hair over the collar using sepia and an extra small round brush.

Young Woman

In this painting, the neutral colors of the background and clothing allow the woman's features to be the focal point of the painting. The neutral palette also emphasizes her quiet mood.

PALETTE

- **Burnt sienna**
- **Cerulean blue**
- **French ultramarine blue**
- **Permanent rose**
- **Quinacridone magenta**
- **Raw sienna**
- **Sepia,**
- **Titanium white**
- **Viridian green**

1 Lightly sketch the design and draw each shadow area using an HB pencil.

2 With a flat 2″ brush, wet the skin tone areas. Then lay in the first wash, a mix of permanent rose and raw sienna, over the entire area. Allow the color to go into her hair, as you can often see the scalp through strands of hair. After this dries thoroughly, apply a wash of cerulean blue and sepia with enough water to match the lightest light of her top. The cerulean blue leaves a nice granulated texture.

As watercolors dry, their intensity lightens by about 30 percent. To test colors, paint a sample and let it dry to make sure it is dark enough.

2

3

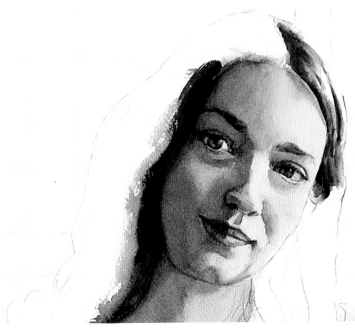

4

3 Paint the large shadow area as one shape by wetting the area with a 2″ brush and floating in a watered-down mixture of permanent rose, raw sienna, and a touch of French ultramarine blue. Then break down the shadow into smaller, darker values. Use the same colors but with less water, more pigment, and a smaller round brush. As you go along, drop in individual colors where you perceive a change, a little extra permanent rose, for instance, in a warmer area. To compare the skin tones to the darkest dark, paint a small area of hair with a mixture of French ultramarine blue and sepia.

4 Cover the eye highlights with frisket. Once dry, wet the iris and lightly drop in burnt sienna with a medium round brush. While damp, add sepia around the edges. Mix sepia and French ultramarine blue for the pupil. Once dry, remove the frisket and lightly add cerulean blue to the "white" of the eye. Paint the lashes as one shape using sepia mixed with French ultramarine blue. Paint the ball of her nose with a mix of permanent rose, raw sienna, and French ultramarine blue. Mix permanent rose and sepia for the nostrils. Wet the mouth and drop in a watery mix of permanent rose and French ultramarine blue. Wet the eyebrows and float in a dark mix of French ultramarine blue and sepia with more pigment in the centers.

5 Wet the background and loosely lay in washes of cerulean blue, viridian green, sepia, and a touch of raw sienna. Let the background dry and then start the hair. For the lighter areas, use burnt sienna, sepia, cerulean blue, French ultramarine blue, and a touch of viridian green. For the darker areas, use a very concentrated mix of French ultramarine blue and sepia, with touches of burnt sienna.

6 Finish her clothing by applying a concentrated mix of French ultramarine blue and sepia in the shadows and touches of cerulean blue and viridian green in the lighter areas. Use titanium white, which is an opaque paint, to soften edges where needed, lighten areas, and add highlights (such as in the eyes and on the lips). Darken additional areas of the background with washes of French ultramarine blue, sepia, and viridian green.

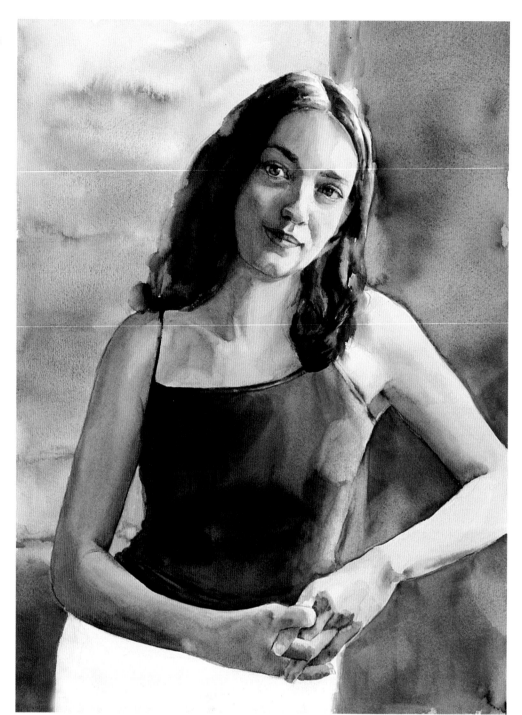

5

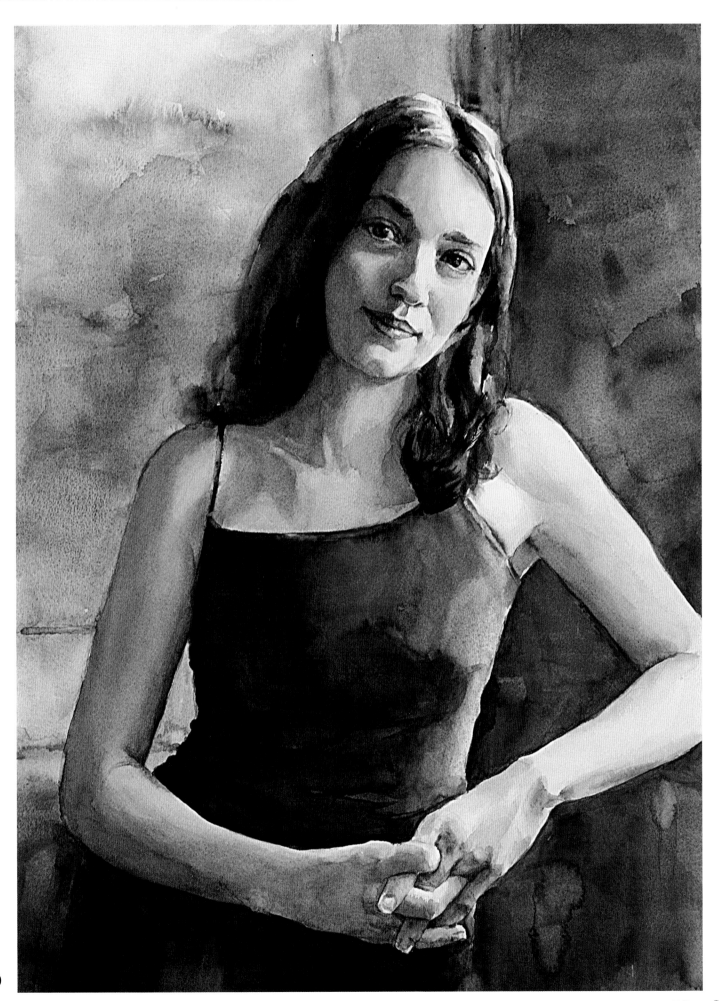

Elderly Gentleman

PALETTE

- Burnt sienna
- Cadmium red
- Cerulean blue
- French ultramarine blue
- Permanent rose
- Quinacridone magenta
- Raw sienna
- Sepia
- Scarlet pyrrol
- Viridian green

1 Draw the image on watercolor paper and include the shadows and highlights. Before you start painting, add a tiny bit of liquid frisket to the highlights in the eyes and along the tip of the nose.

2 With a 2" flat brush, lay in a light mixture of raw sienna and permanent rose over the face and hands. Paint the light shadows on his shirt collar with cerulean blue, raw sienna, and permanent rose. Start on the red sweater with a mix of quinacridone magenta and scarlet pyrrol to make sure the red works with the skin tones. Paint the collar of his jacket on the left with a mixture of French ultramarine blue and sepia.

Moving the painting to an easel allows the paint to run and mix on the paper.

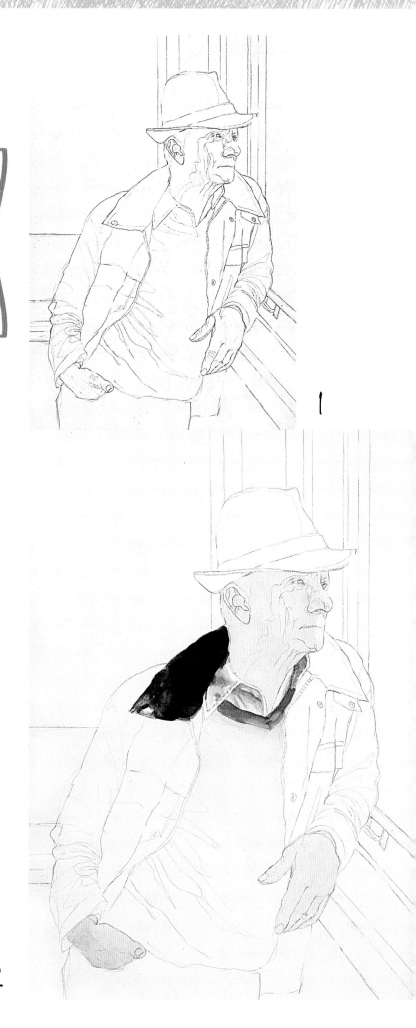

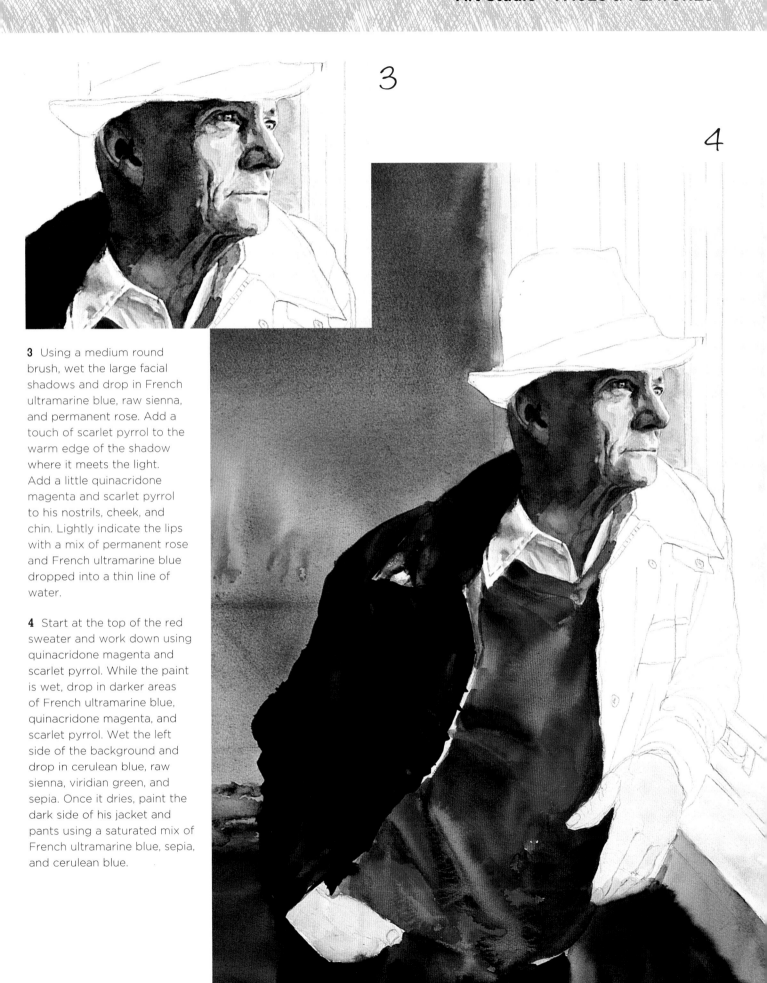

3 Using a medium round brush, wet the large facial shadows and drop in French ultramarine blue, raw sienna, and permanent rose. Add a touch of scarlet pyrrol to the warm edge of the shadow where it meets the light. Add a little quinacridone magenta and scarlet pyrrol to his nostrils, cheek, and chin. Lightly indicate the lips with a mix of permanent rose and French ultramarine blue dropped into a thin line of water.

4 Start at the top of the red sweater and work down using quinacridone magenta and scarlet pyrrol. While the paint is wet, drop in darker areas of French ultramarine blue, quinacridone magenta, and scarlet pyrrol. Wet the left side of the background and drop in cerulean blue, raw sienna, viridian green, and sepia. Once it dries, paint the dark side of his jacket and pants using a saturated mix of French ultramarine blue, sepia, and cerulean blue.

Touching a wet brush to almost-dry paint is usually discouraged. This creates a "bloom" effect as the water pushes the pigment to the edges of the water drop and leaves a lighter area in the center. But you can also do this on purpose to add texture and interest in select areas, such as on the bottom of his sweater.

EYE DETAIL Wet the irises and drop cerulean blue in the centers. Add small dabs of French ultramarine blue to the outer edges and let it mingle with the cerulean blue. Once this dries, remove the frisket and add a little sepia and French ultramarine blue to create his pupil and upper eyelashes.

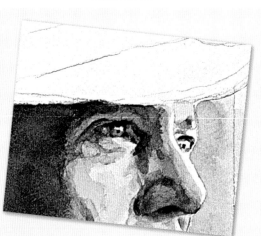

5 Proceed with the rest of the background using a wash of cerulean blue and raw sienna. After it dries, add definition to the window, frame, and sill with colors already mixed on your palette: French ultramarine blue, sepia, scarlet pyrrol, and raw sienna. Once the background dries, paint the rest of the jacket with French ultramarine blue, sepia, and a little raw sienna. To give the jacket a worn look, dip a round brush scrubber in water, dab it on a paper towel, and lightly scrub the paint from small areas. Add sepia to indicate his hair.

HAT DETAIL Using a large round brush, wet the areas above and below the hatband and drop in a mix of cerulean blue and sepia. Use extra sepia on the left, as well as along the seam and underside of the brim. Add a touch of cadmium red on the brim. For the band, drop in raw sienna and a little sepia. While it's wet, create the textured lines using a medium round brush and a mix of sepia and cerulean blue.

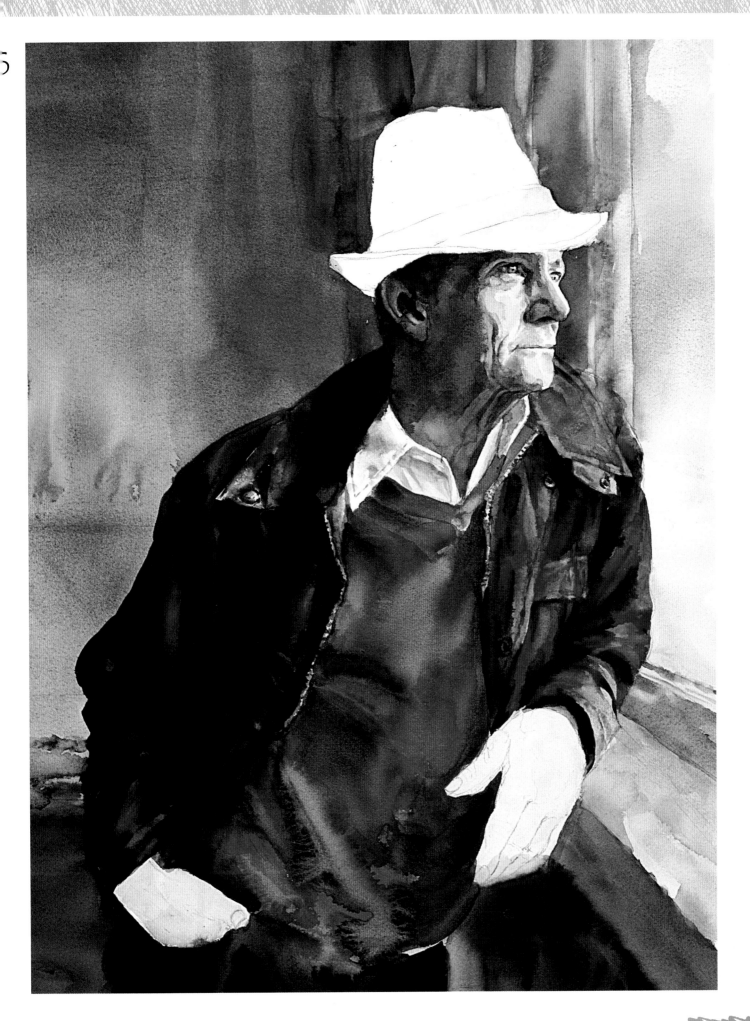

Paint older skin with restraint. Your portrait will not be very flattering or realistic if you try to paint every character line and wrinkle or if you paint them too dark. Select only a few of the prominent lines to paint.

HANDS DETAIL Lay down several washes of raw sienna, permanent rose, and French ultramarine blue. For the hand resting on the right, use a more delicate touch and less blue. For the other, add more blue until the value almost matches the pants. This creates a "lost edge. When something is in shadow, such as this hand, the edges are fuzzier and will have less contrast. Wet the shape or line of the wrinkles and veins and carefully drop in watered-down color. The values of the wrinkles and veins are only slightly darker than the surrounding areas. If the color is too dark, dab it with a damp brush. Paint his fingers as a series of simple shapes.

6 To balance out the composition, darken the background area behind the man's hat with a mix of viridian green, cerulean blue, and sepia. Once it dries, add more facial color with a mix of permanent rose and raw sienna. Carefully add a touch of French ultramarine blue in the shadows as needed. Add a little shadow to the window ledge using a cerulean blue and sepia mix. Below the ledge, use French ultramarine blue and sepia. Add a shadow on the right side of his sweater with a watery mix of scarlet pyrrol, permanent rose, cadmium red, and sepia.

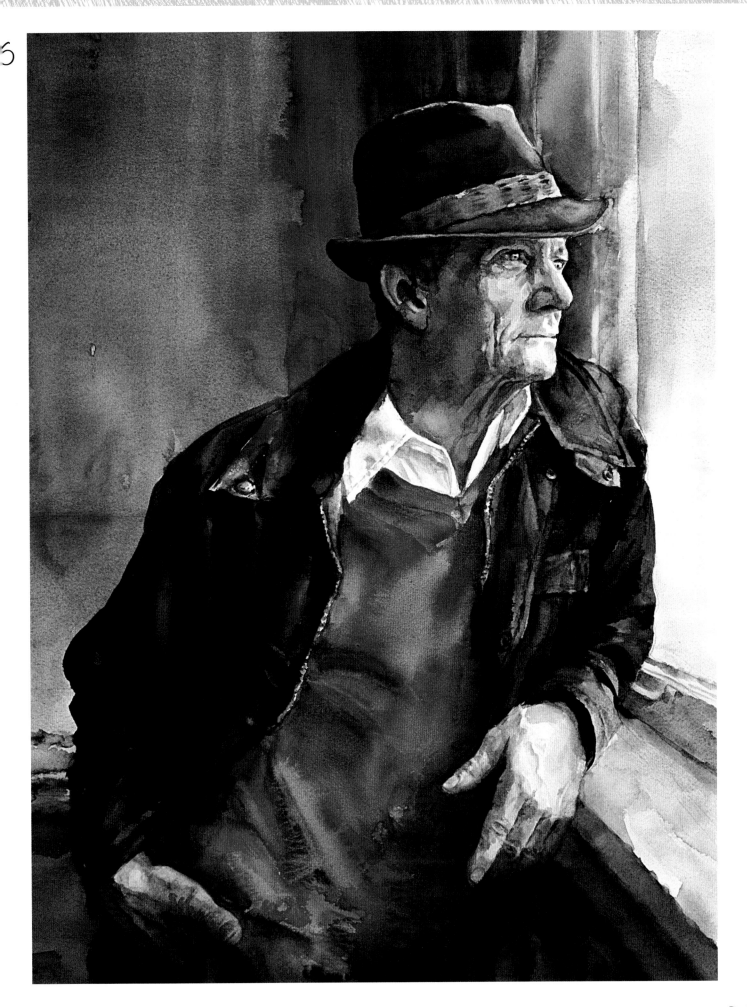

PASTEL

Young Girl

1 The first marks are extremely important as they set the course for both the location and size of the portrait. This lovely blue-gray paper is larger than necessary; you can always crop in later as the portrait develops. Use vine charcoal to make four light marks to indicate the top of the head, the hairline, the bottom of the chin, and the edge of the composition at the bottom. These four marks set the scale and the location of the head in the composition.

2 Locate the shape of the head and lightly sketch with vine charcoal. Use straight lines to indicate angle changes. Work around the floral headband, capturing the basic shape. Then indicate the angle of the shoulders with a diagonal line. Next work on the facial features. Locate the eyes and state the darks of the eyebrows. Draw the shoulders and torso, relating the shapes to the head above in order to find their locations.

1

Top of head

Hairline

Bottom of chin

Composition edge

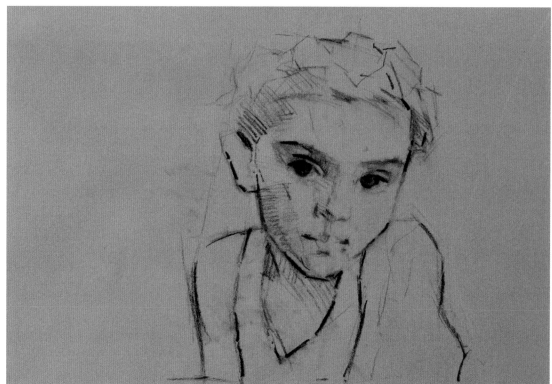

2

3

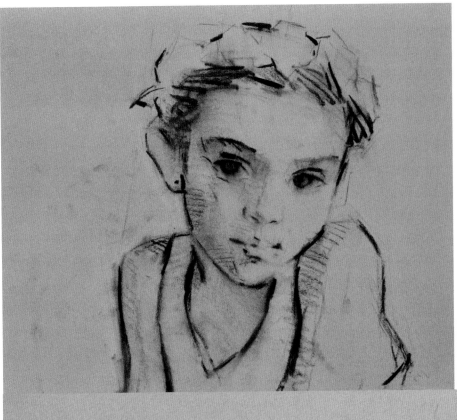

3 Darken the edges and tone in the shadows with vine charcoal. This creates a visual map for the portrait as we begin to paint with pastel. Use a hake brush to lightly wisp over the drawing and release any loose charcoal in preparation for the next stage.

4 Using soft pastel, mass in the shadows with side strokes of umber. Start with a middle-dark value a little darker than the paper to establish the mass; we will go darker later. Next use reddish dark brown to restate some of the drawing over the vine charcoal. These linear strokes of pastel secure the drawing more firmly, as vine charcoal tends to fade easily. Push the darks further by using side strokes of warm sienna soft pastel.

4

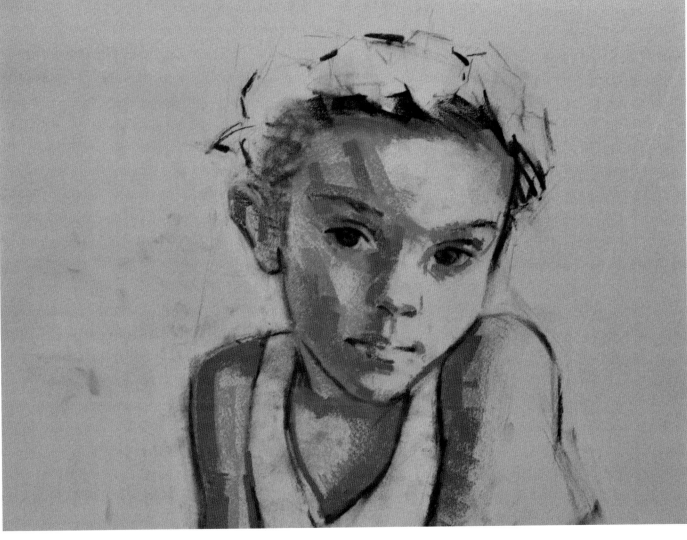

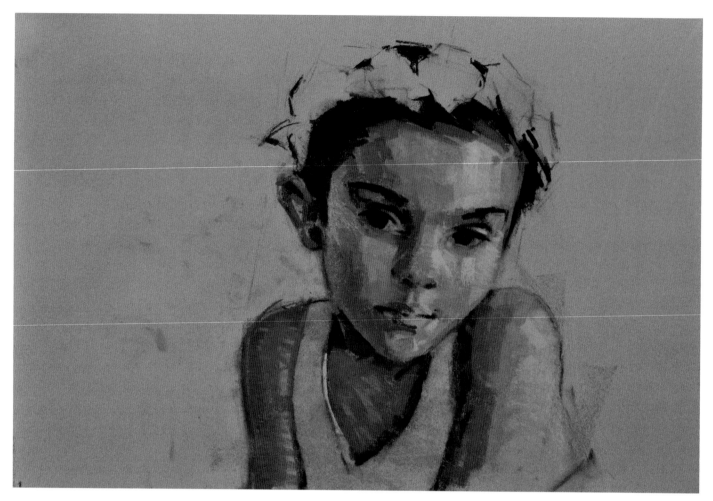

5 It's time to establish the warmer skin tones on the lighter side of the face and
arms. Use side strokes with smaller pieces of soft pastel in these areas, rather than
lots of linear strokes. Use a warm peach in the middle of the face and on the arms
to transition the light and shadow area. Then use soft black pastel to strengthen the
darks in the hair, eyes, and eyebrows, pushing the value to the extreme. Use dark
chocolate brown to deepen the shadows by the hair, under the chin, and at the
edges of the blouse.

6 Begin the background with large broad multidirectional strokes, creating dynamic
energy and excitement. Start with various shades of violet grays. Going back to
the girl, begin massing in more color, adding broad strokes of pink to the floral
headband to indicate the roses. Use pink and mauve in the midtones of the face and
arms. Next use linear strokes of scarlet red in the inside corners of the eyes, around
the nostrils, and throughout the lips. Add red accents to the ears and cheeks at the
edge of the lit side of the face.

7 Restate the darks with brown along the left edge of the face, the bridge of
the nose, around the eye sockets, and the lips. Then add light blue notes into the
background on the left side, clarifying the edge of the head and ear. Add light pink
to the roses in the hair to begin shaping the flowers. Next add more layers of blue,
violet, and purple to the background. Add lush vibrant salmon on the blouse and
face to give the portrait more vibrancy and glow.

5

6

7

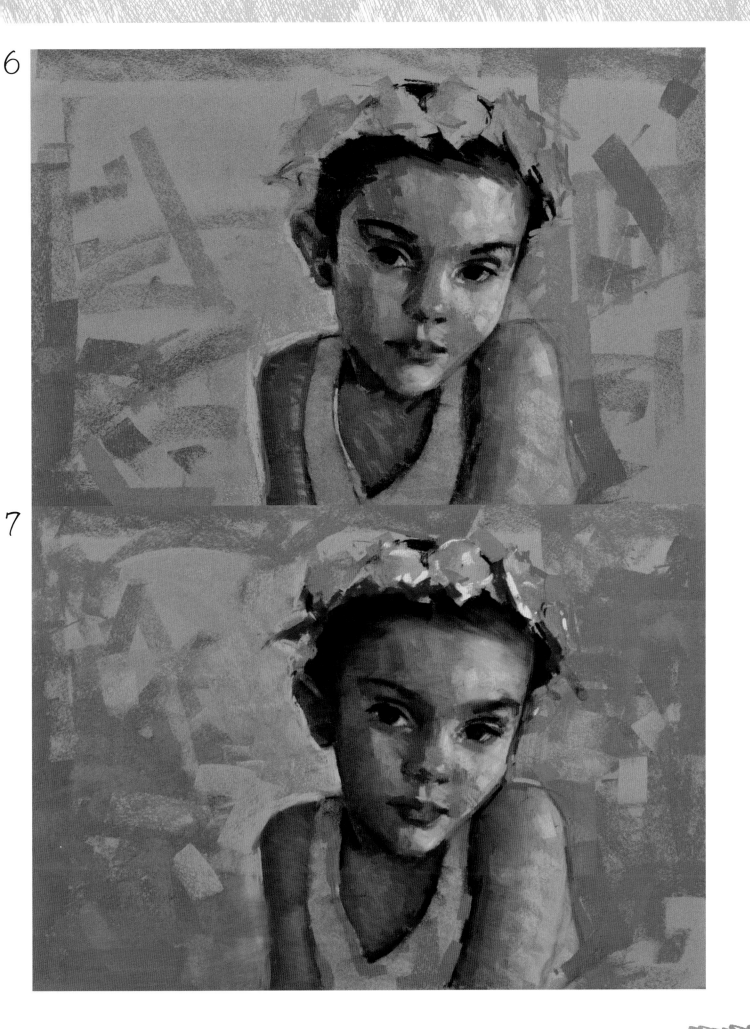

8

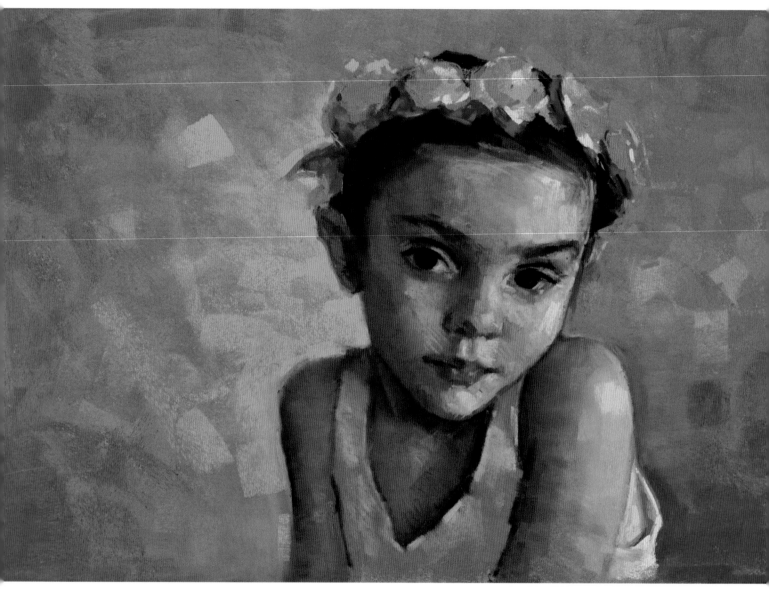

8 Using dark brown and black again, restate the darks in the hair and in the shadow areas of the torso and arms. Use umber browns in the midrange between the hair and face to transition the forehead. Then use both soft and hard pastels to continue developing the midrange in the darks and lights, creating more subtle gradations from dark to light. Don't be afraid to take risks with color, letting your intuitive side play. Experiment with some teal blue to the left of the head.

9

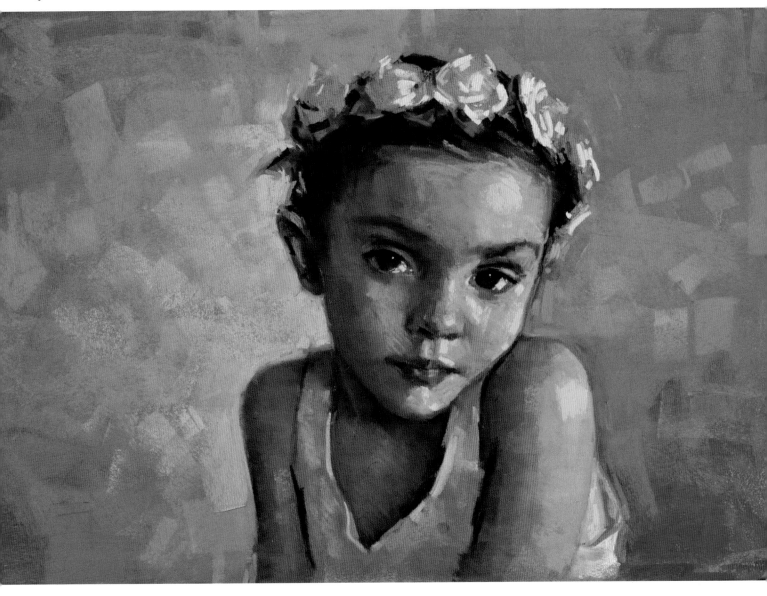

9 Begin to add thicker, bolder strokes of light pink and violet in the roses of the floral headband and throughout the light side of the face. Add some bold strokes of pink in the blouse as well. Then add deep red strokes in the flowers, hair, face, and ears to give a feeling of life. Add a few dashes of orange throughout the face and arms to add visual excitement.

10

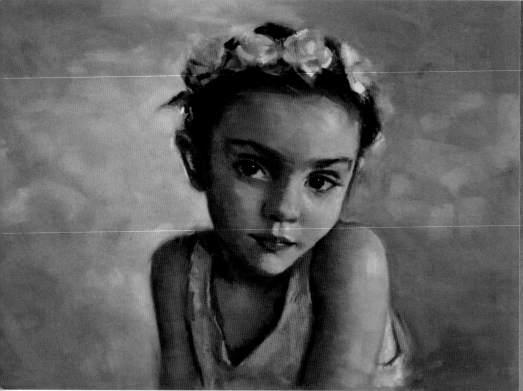

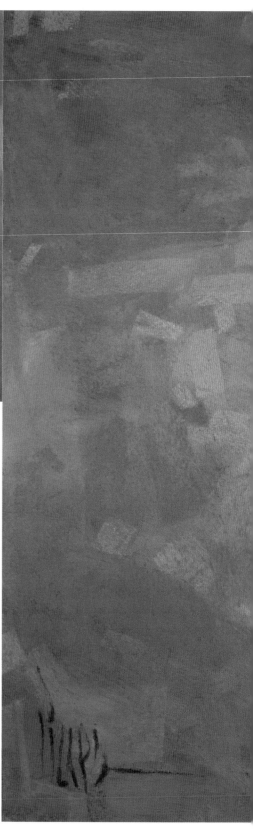

10 After many layers of pastel strokes, it's time to quiet down the texture of the painting and fuse the edges. Use a paper towel to gently blend the background. Using a soft hake brush, carefully blend the face and arms with light wisps of the brush. You can use your fingers in more sensitive areas of blending.

11 The final stage is about moving through the darks, middles, and lights of the painting once more to refine the drawing, clarify the values, enhance color, and adjust edges. Build up the floral headband with fresh marks again, as well as the background. Use more hard pastels in the face at this last stage to execute the smaller details around the features, focusing a lot of attention on the eyes. Place a small crisp highlight in each eye, using a sharpened white hard pastel. Use a black hard pastel for the pupils and the eyelids to really make them stand out.

11

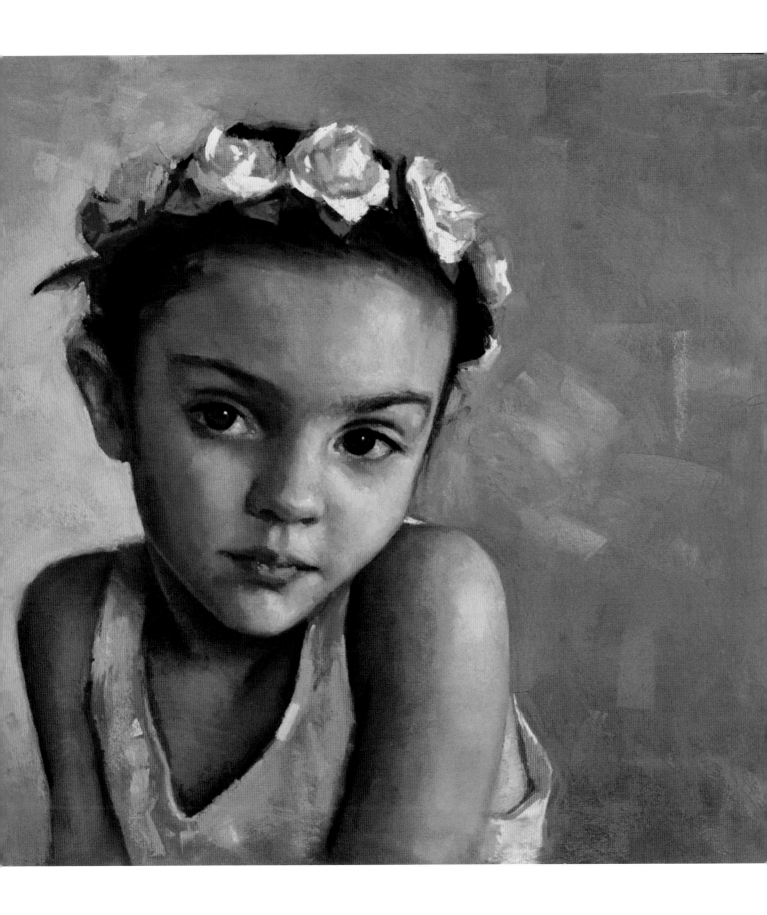

Young Bride

A great painting always begins with the spark of an idea, but it succeeds as a result of thoughtful planning. It's important to let your inspiration guide you and paint subjects that interest you artistically. For this project, we'll paint a beautiful Victorian bride.

LIGHTING & PHOTO SESSION Lighting is crucial, as it has a significant impact on the mood of the portrait. For this photo the light source is a 24" x 32" softbox—a soft light source that cast 750 watts of tungsten light on the model's face and torso. The light source is placed on a light stand about 4 to 5 feet away from the model, positioned slightly above and to the left of her face. The off-center position results in a strong, clear pattern of light and shadow across her face and creates lovely catchlights in her eyes. The softbox also produces a soft edge on the model's face at the turn of the form between light and shadow. This lighting approach is called three-quarter portrait lighting. An additional small 200-watt spotlight just behind and to the right of the model, directed at the background, illuminates and separates the blue drapery from the shadow side of head.

SCALING THE HEAD The head should be life-sized in the final portrait. If it's too large, it can appear incorrect or garish, particularly if it is a young female head. A simple measurement of the model's face with a standard ruler will provide the dimensions needed to accurately scale the portrait. In this case, the model's face is 7½" from the chin to the hairline and 9½" from the chin to the top of the head. The dimensions for this portrait will be roughly 16" x 24" with room to adjust if needed.

9.5"

7.5"

PREPARING THE SURFACE
This demonstration is done on white, museum-grade sanded pastel paper mounted to pH-neutral, 3/16-inch black Gatorboard. This stable surface can withstand multiple layers of pastel, as well as underpainting techniques.

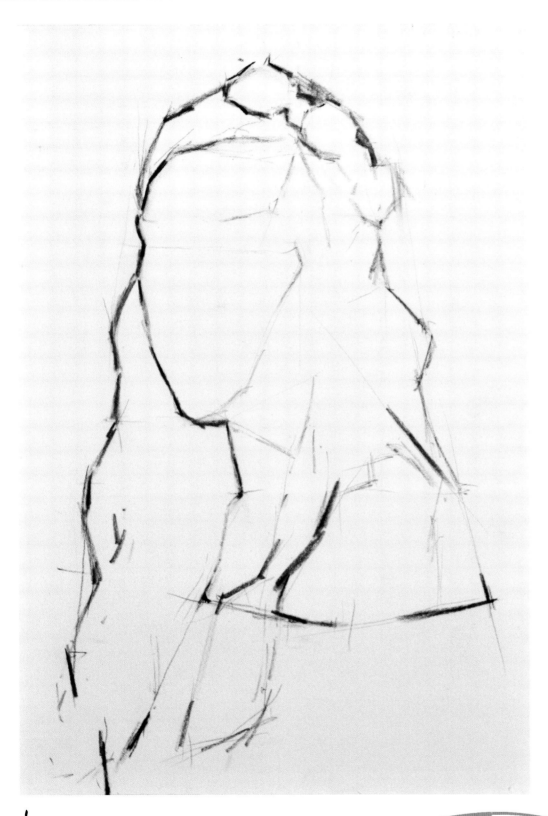

1 Begin with soft willow charcoal, an excellent tool for initial sketching because of its forgiving nature. Start by indicating the bottom of the chin, the hairline, and the top of the head. These important marks set the course for the scale and location of the entire portrait to follow. With the marks in place, sketch the outside edge of the head, the basic shape of the draping hair mass, and the flower crown and blouse. Take time to measure and find the proper locations for each element in relation to the head.

Create a few sketches to get your hand moving and connecting with the shapes. These sketches, or *thumbnails*, serve as visual problem-solving tools that help resolve shape, value, and design choices before beginning the painting.

2 Begin toning the shadow masses with willow charcoal. Sketch the smaller shapes of the face, such as the eyes, nose, and mouth, continuing the pattern of shadows cast by the nose and lips. At this stage, keep your focus on simple shapes and avoid drawing details.

3 For the final sketching stage, mass in the darker tones of the hair and background using the sides of the vine charcoal. Unify and simplify the tone by blending with a hake brush and stumps. Quickly restate a few outside edges and features to clarify the division of shapes, as blending can diffuse them. Finally, use a kneaded eraser to create a few key highlights.

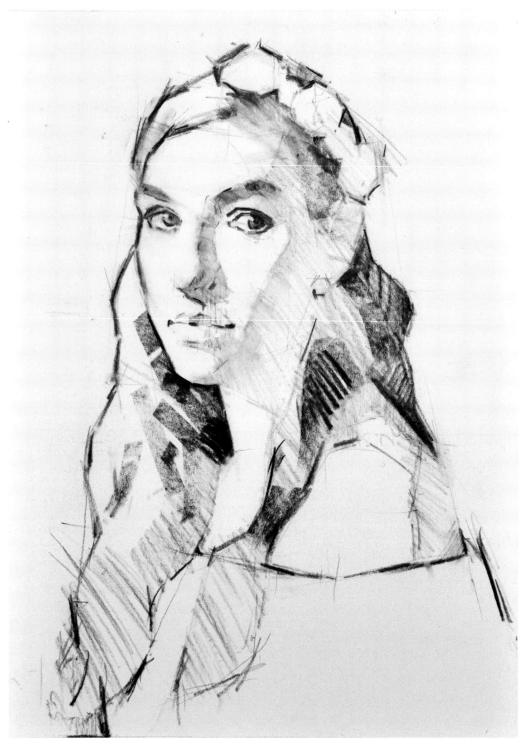

2

3

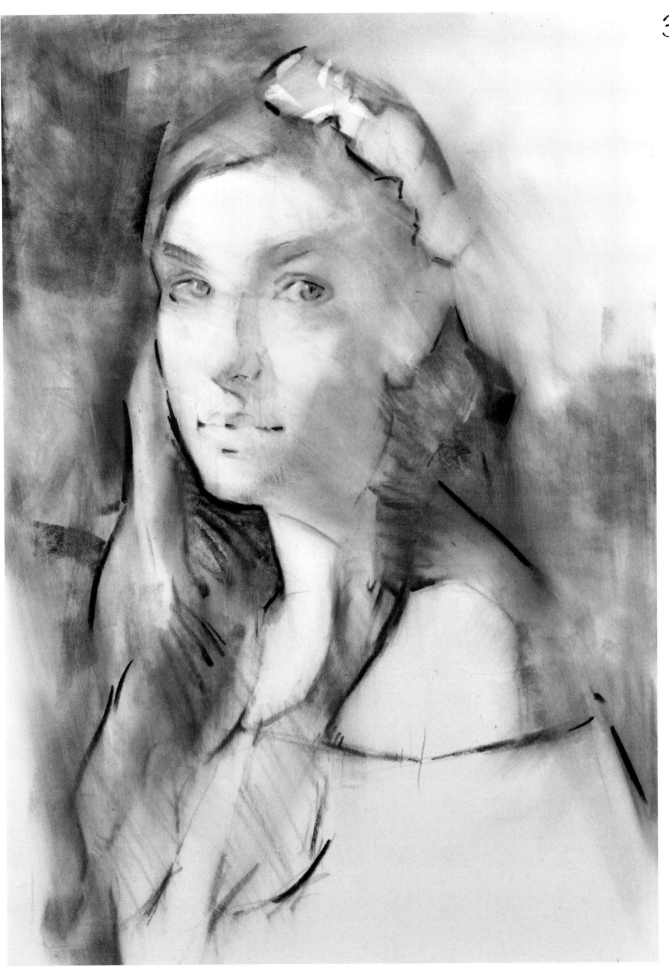

4 When you switch to colored pigment, start by massing in the darks. The model's hair and skin tone both call for a great deal of brown, burgundy, and reddish ochre. Focus on the shadow shapes of the hair, face, and shoulders, using mostly side strokes of hard and soft pastels applied with a very light touch. Next use broad side strokes to mass in the dark blue and gray of the background.

5 Using a wash stains the pigment into the surface of the sanded paper, which opens up additional paper tooth for subsequent layers. Using a flat watercolor brush and 70-percent denatured alcohol, begin applying alcohol washes over the dry pigment, taking care not to wash the darks into the lightest lights.

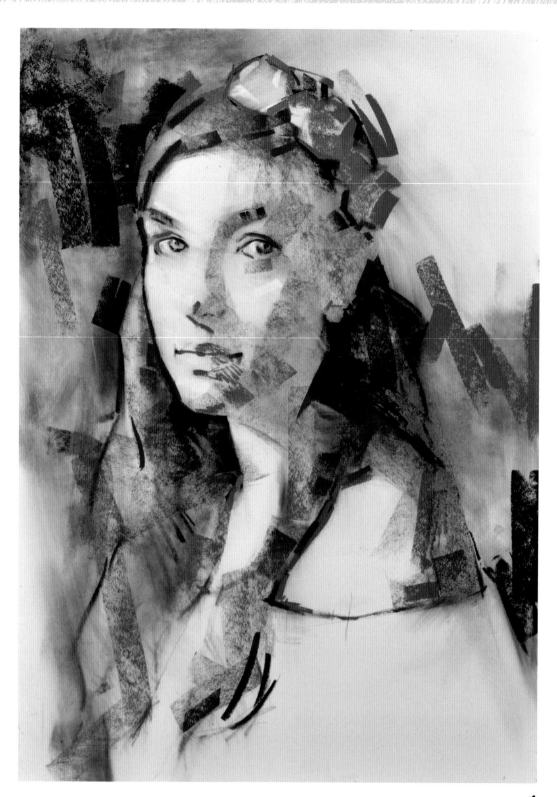

4

As you work, keep in mind that every painting stroke is a drawing stroke, because it impacts the form through color temperature, value, and shape.

5

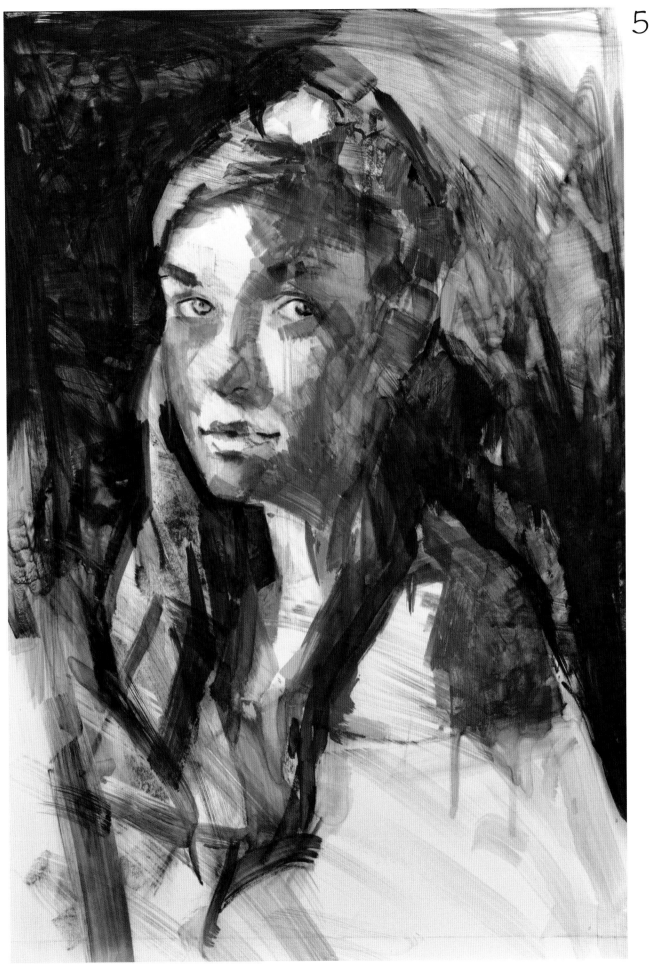

6 The washes diffuse and slightly distorted the image, so it's necessary to restate the drawing. Start by restating the rich, warm darks of the hair and add a bit of striking deep blue and green to the background. Then begin building up the skin tones with middle and light values in ochre, pink, and light umber. Finally, add more saturated midtones to the hair and background to push the color intensity.

7 Revisit the alcohol wash technique to create a soft atmosphere in the background, hair, and foreground blouse. Use the broad sides of paper blending stumps to scumble and burnish the pigment into the paper. Next build up painterly marks in the flower crown, hair, and skin. Work more carefully around the eyes, nose, and mouth to develop the features. Once again, restate the deep darks and midtones of the hair. Now begin placing opaque lights on the blouse and highlights on the face with soft pastel.

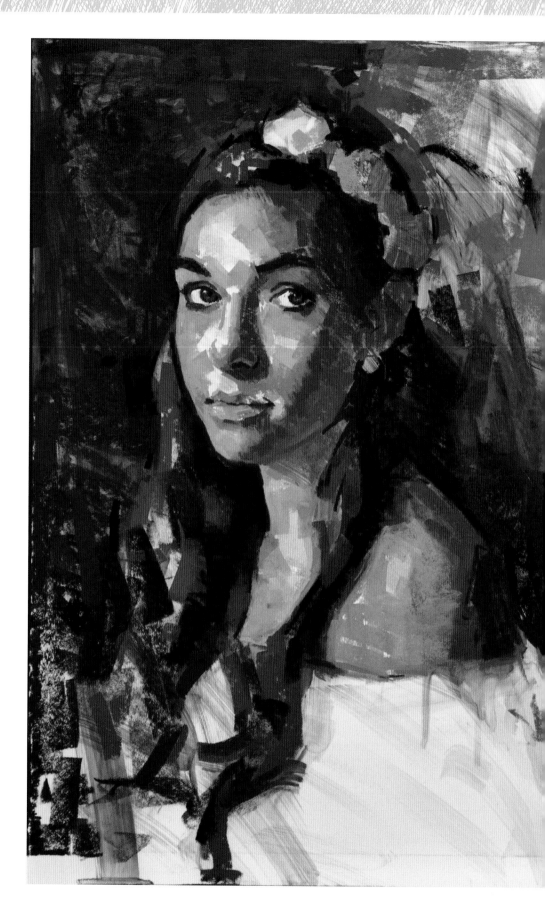

7

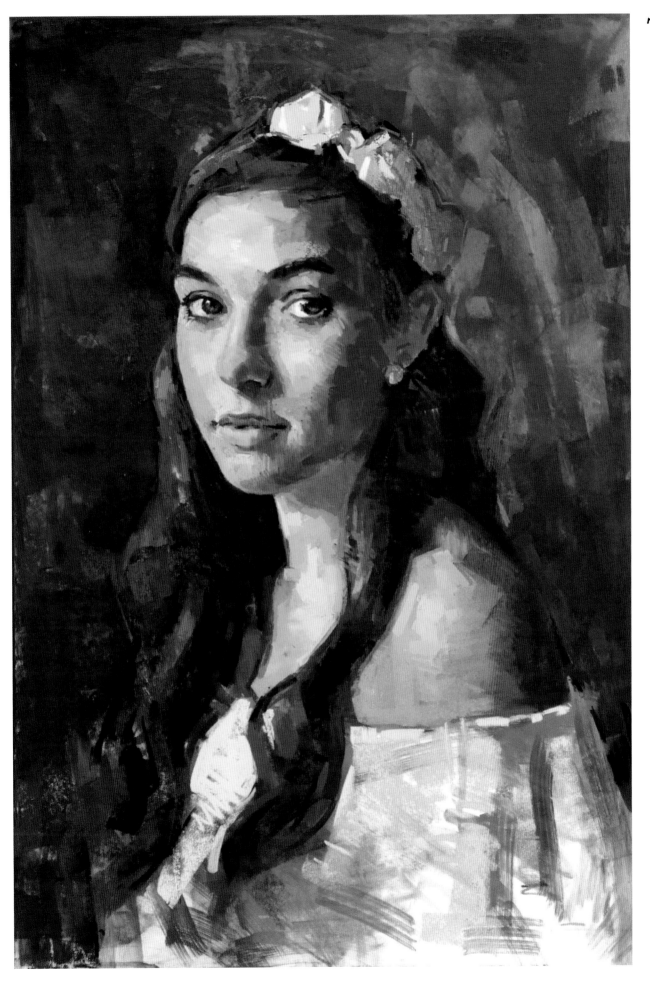

8 If you like, crop an inch off the bottom edge of the composition to eliminate excess blouse. Then begin the lengthy process of refining the portrait, blending and softening edges where needed, and making subtle adjustments to color and shape.

9 Notice the subtle development of the unique textures in the flower crown and blouse. Play with unblended, crisp flicks of saturated color above and surrounding the head. This effect lends a dreamy, ethereal quality to the subject while providing visual stimulation between the warm and cool colors.

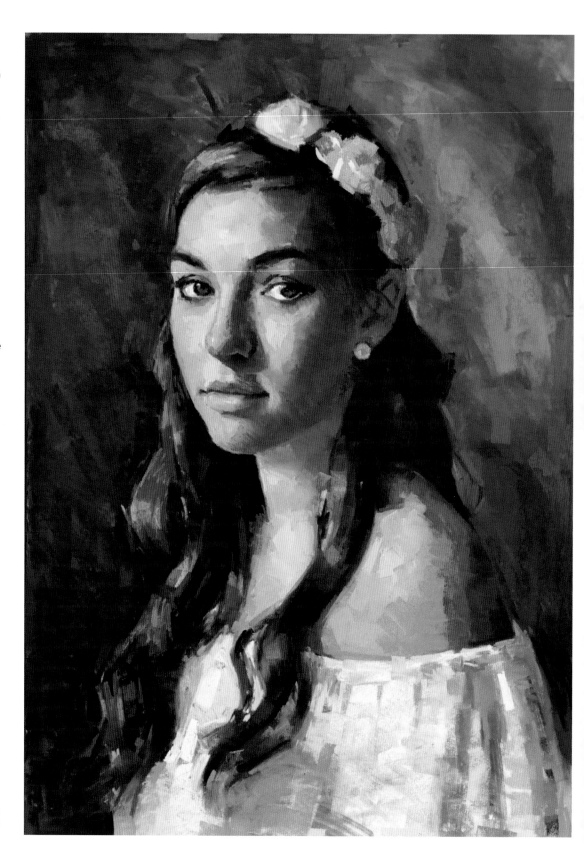

8

9

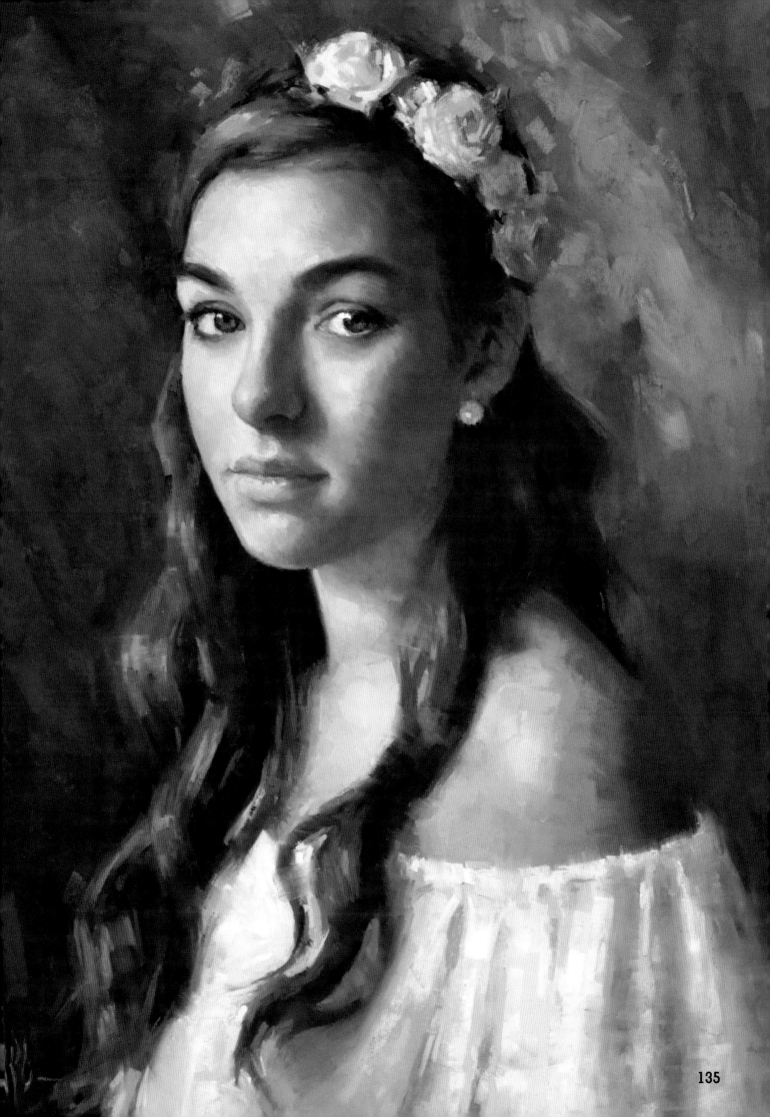

Boy

Use a linear drawing approach called "angularizing" to locate the outside edge of the head and the division of light and shadow in the portrait. As these shape relationships develop, you can easily check the accuracy of your drawing by observing the "anchor points" where angle changes occur.

1 Begin with willow or vine charcoal to scale and place the head on light gray pastel card, mounted to Gatorboard. Block out the shape of the head. Using charcoal, loosely add tone to the shadow areas. Try to construct a basic blueprint for all major shapes in the portrait. Notice how the light and shadow shapes have been abstracted into basic masses, much like jigsaw puzzle pieces. Consider the large negative shapes in the background surrounding the head to be certain they fit together correctly.

2 Before adding color, quickly tone in a bit more dark value with soft vine charcoal, and then soften it using a brush or paper towel. This gives the study a more unified look and embeds the charcoal into the paper before applying color. This is the last chance to evaluate the drawing for accuracy, placement, and design before moving on to the next stage. It's worth taking your time.

2

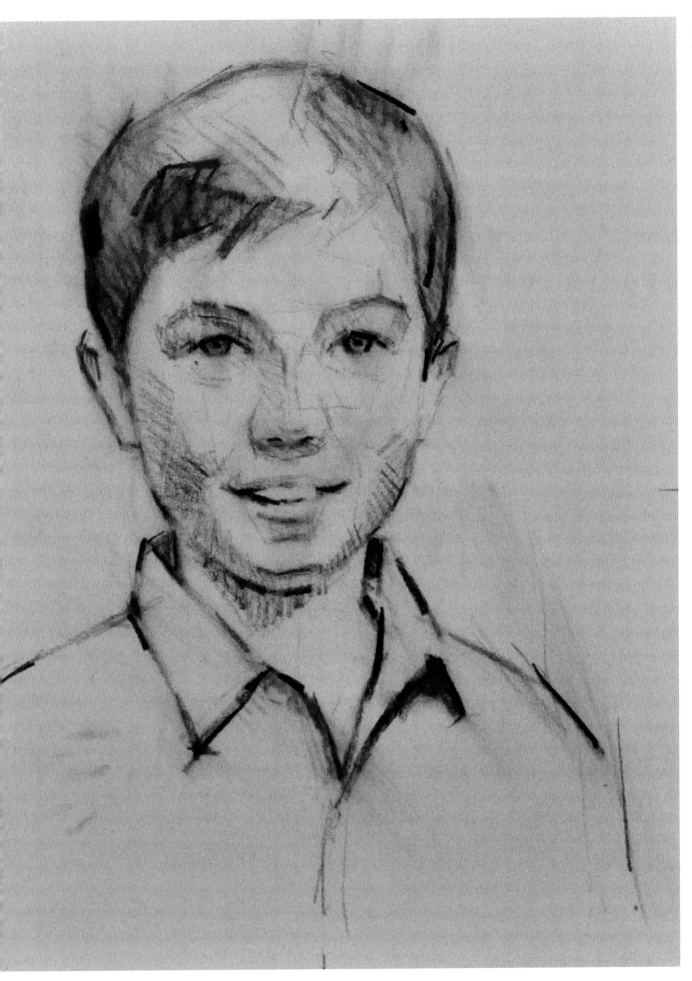

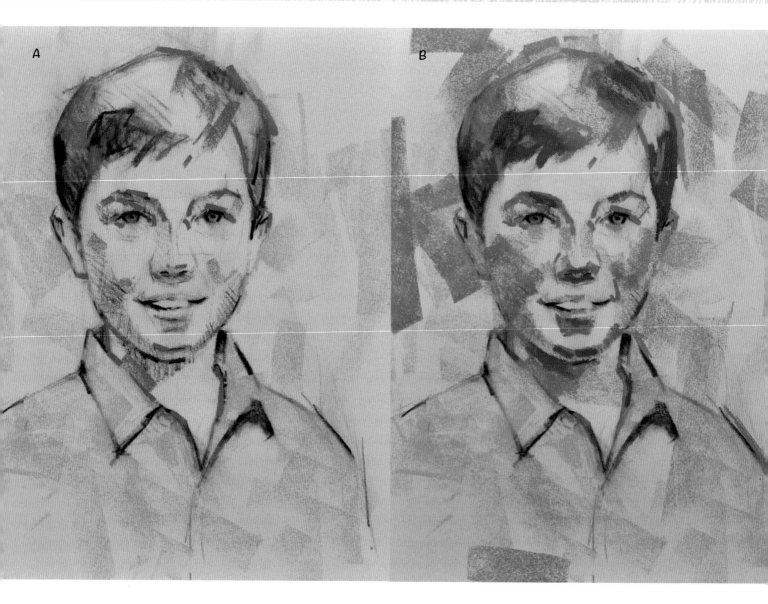

3 The vision for this portrait is to present a vibrant depiction of boyhood, so use bold mark-making to develop the piece. Use a broken color technique by applying bold chops of color in unblended strokes to build up the atmosphere of the work in an impressionistic manner. Begin with a cool gray-green soft pastel to establish atmosphere. Use the full, broad side of the pastel for these large side strokes, moving color around the head and over the shirt to create color harmony (A). Next use an umber soft pastel to divide the dark masses in the hair and face. Moving toward warmer colors in the middle and dark areas, use a flesh color in the cheeks, deep burgundy in the hair, and another warm brown midtone throughout, continuing this choppy, bold painterly approach (B). Switching gears to the background, use a warm greenish-ochre to introduce yellow-green to the palette (C).

3

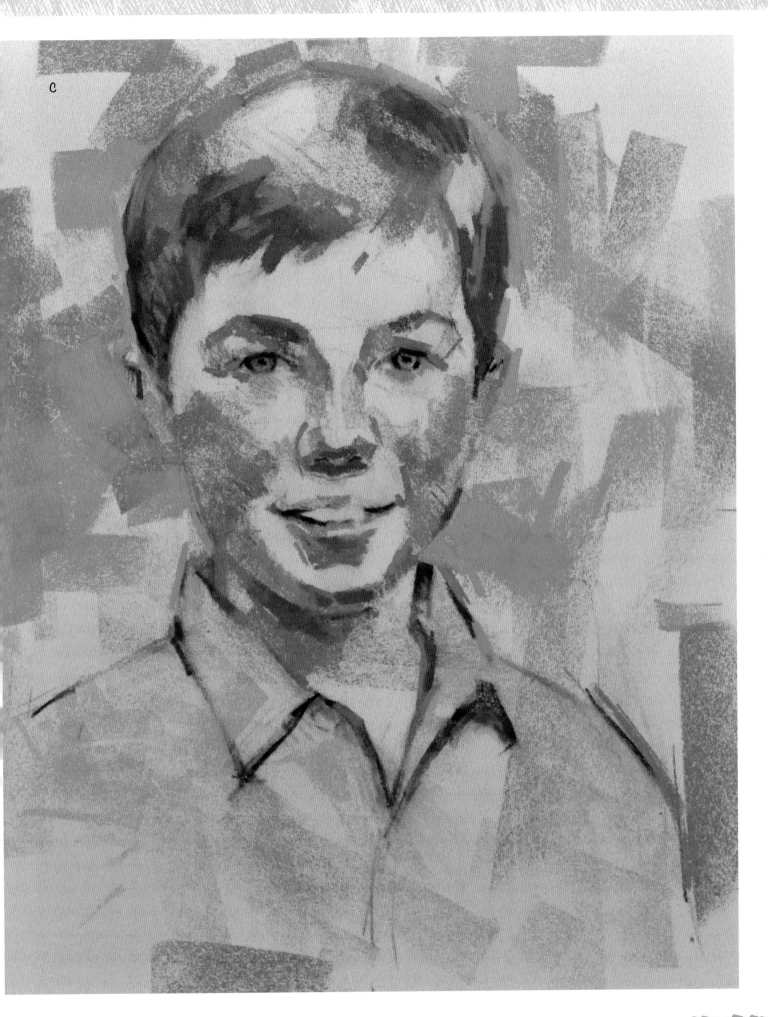

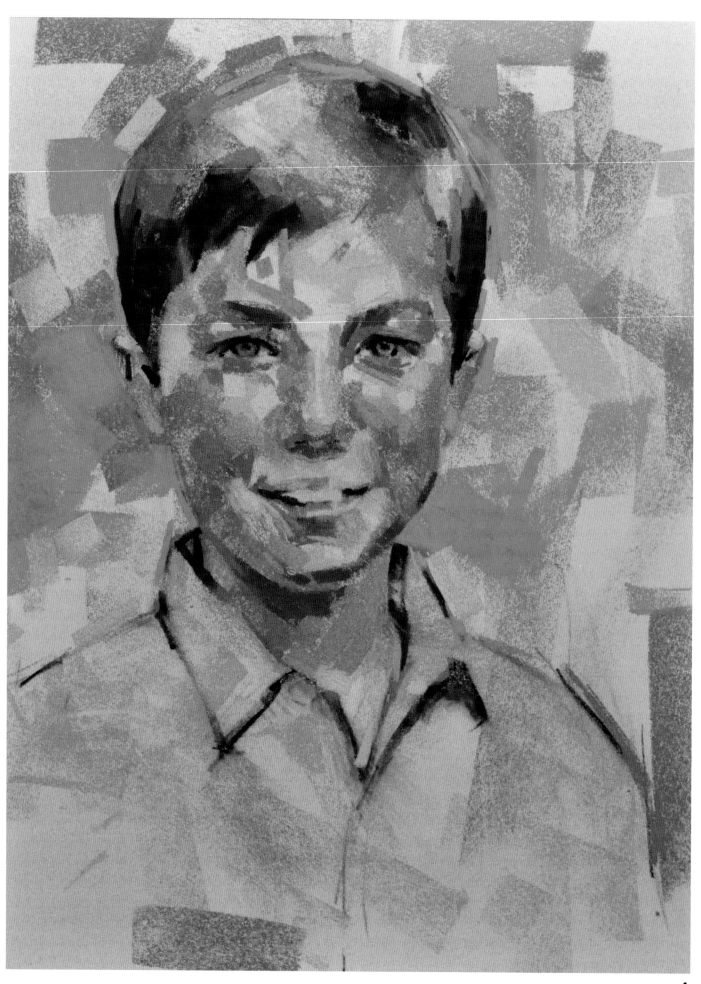

4

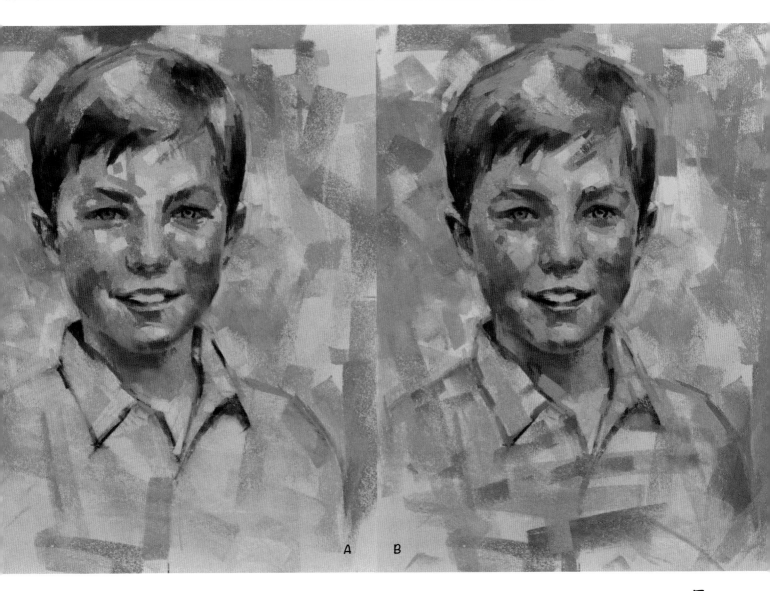

A B

5

4 Anchor the darkest darks using deep burgundy and black soft pastels in the shadow areas of the hair, face, and neck. Then move to the face to establish more of the flesh tones with the same bold, choppy marks, giving the portrait a playful and confident feel. Use the same mauves and pinkish flesh tints that cover the face and neck in the background as well, to harmonize the palette.

5 Switch to violet-gray and introduce this neutral throughout the shirt, background, face, and hair to give the portrait a cool, airy feel. Barely squint your eyes and allow yourself to instinctively place the color wherever it feels necessary, overlapping edges to open up the atmosphere. Select a cool mint green and use it recklessly throughout the shirt and background (A). Integrating these cool tints with warm passages enhances the atmosphere around the head. Apply subsequent layers of pigment, including yellow ochre, cobalt blue, blue-gray, and moss green in multiple values, with additional flesh tints of warm reds, neutral flesh tones, and cool grays in the face (B).

Using similar colors throughout the whole painting creates color harmony. Try using colors from the face, hair, and shirt in the background. Then find ways to use background colors in the face, hair, and shirt.

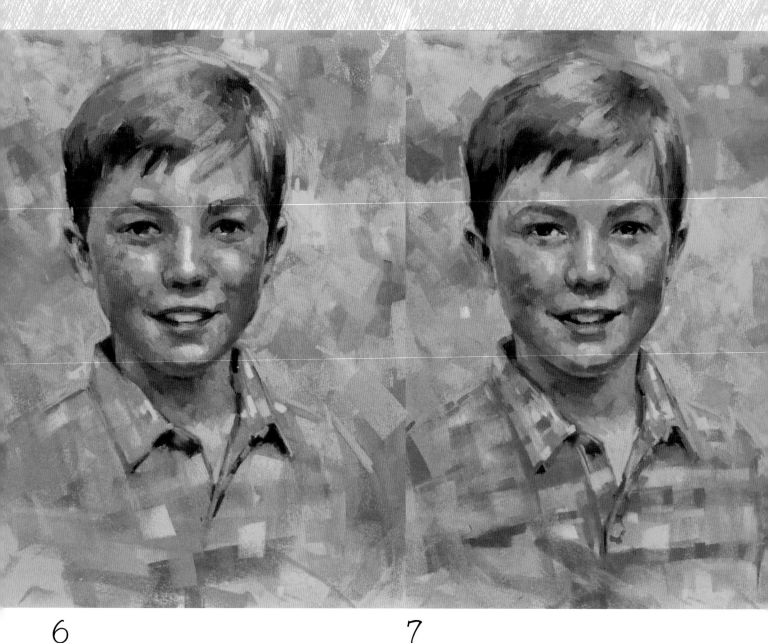

6 7

6 The later stages of the painting require a good deal of time to develop additional layers of pigment. Within the flesh tones of the face, carve out the features with a sculptural approach to mark-making, changing the direction of the strokes according to the turn of the form. Add accent colors to the shirt with turquoise blue. All the while, build up beautiful layers of pigment composed of many overlapping strokes of color and textures. This buildup of pigment affords the viewer a very satisfying visual feast.

7 Refine the portrait, paying close attention to the likeness and carefully developing the subtle details of the features. Add more lights to the face to push the value contrast further, and round out the head as a three-dimensional mass. Meanwhile, continue to experiment with bold notes of color and unusual accents, such as cadmium yellow, lavender, chrome green, and teal. It's amazing how small flicks of color can communicate such life! Develop the suggestion of the shirt pattern by interlocking strokes of blues and greens.

8 When doing a commissioned work, it's a good idea to give the client the opportunity to present feedback at the final stage of the portrait, and then I make final revisions at their request. In this case, Jack's mother provided feedback that brought about subtle adjustments to the eyes, lips, teeth, and upper bridge of the nose between the eyebrows. Although minor, these suggestions contributed to a stronger final portrait, and also resulted in a greater sense of satisfaction between the client and artist at the close of our collaboration. The resulting portrait of Jack is a vibrant, expressive, and colorful depiction of boyhood.

8

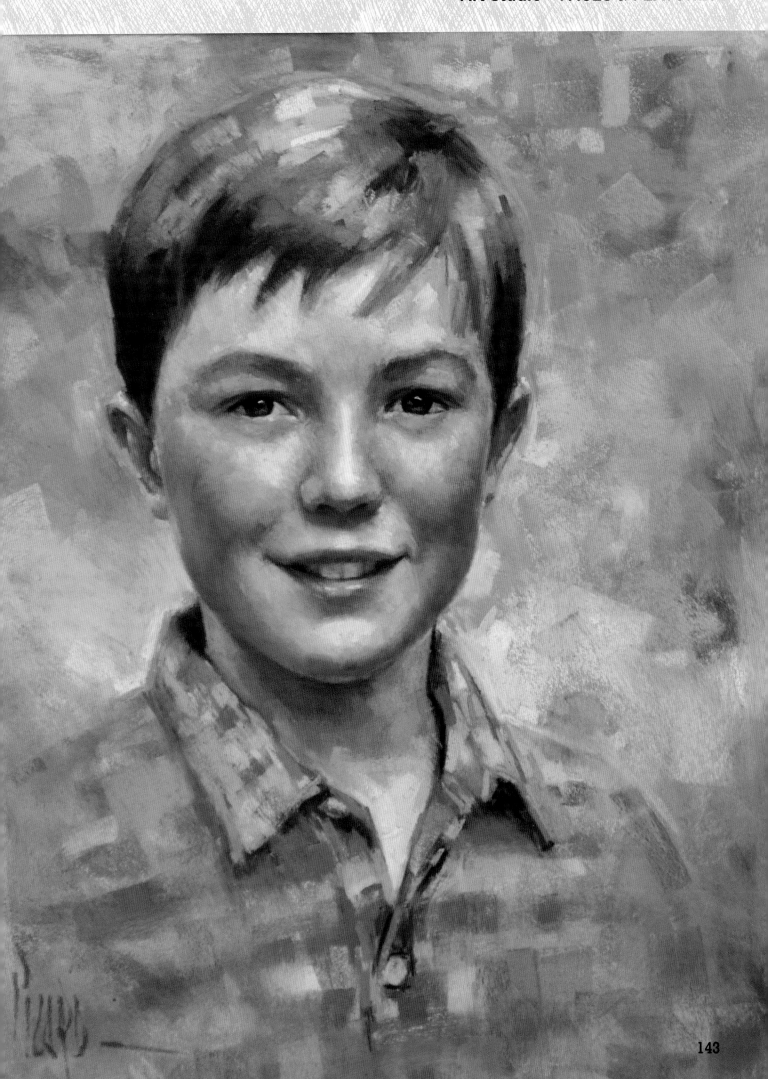

ALSO IN THIS SERIES

978-1-63322-364-6

978-1-63322-363-9

978-1-63322-695-1